THE AGILE RABBIT VISUAL DICTIONARY OF

VEGETABLES

The Pepin Press – Agile Rabbit Editions

Graphic Themes & Pictures
90 5768 001 7 1000 Decorated Initials
90 5768 003 3 Graphic Frames
90 5768 007 6 Images of the Human Body
90 5768 012 2 Geometric Patterns
90 5768 014 9 Menu Designs
90 5768 017 3 Classical Border Designs
90 5768 055 6 Signs & Symbols
90 5768 024 6 Bacteria And Other Micro
 Organisms
90 5768 023 8 Occult Images
90 5768 046 7 Erotic Images & Alphabets
90 5768 062 9 Fancy Alphabets
90 5768 056 4 Mini Icons
90 5768 016 5 Graphic Ornaments (2 CDs)
90 5768 025 4 Compendium of Illustrations (2 CDs)
90 5768 021 1 5000 Animals (4 CDs)

Textile Patterns
90 5768 004 1 Batik Patterns
90 5768 030 0 Weaving Patterns
90 5768 037 8 Lace
90 5768 038 6 Embroidery
90 5768 058 0 Ikat Patterns

Miscellaneous
90 5768 005 x Floral Patterns
90 5768 052 1 Astrology
90 5768 051 3 Historical & Curious Maps
90 5768 061 0 Wallpaper Designs

Styles (Historical)
90 5768 027 0 Mediæval Patterns
90 5768 034 3 Renaissance
90 5768 033 5 Baroque
90 5768 043 2 Rococo
90 5768 032 7 Patterns of the 19th Century
90 5768 013 0 Art Nouveau Designs
90 5768 060 2 Fancy Designs 1920
90 5768 059 9 Patterns of the 1930s

Styles (Cultural)
90 5768 006 8 Chinese Patterns
90 5768 009 2 Indian Textile Prints
90 5768 011 4 Ancient Mexican Designs
90 5768 020 3 Japanese Patterns
90 5768 022 x Traditional Dutch Tile Designs
90 5768 028 9 Islamic Designs
90 5768 029 7 Persian Designs
90 5768 036 X Turkish Designs
90 5768 042 4 Elements of Chinese
 & Japanese Design

Photographs
90 5768 047 5 Fruit
90 5768 048 3 Vegetables
90 5768 057 2 Body Parts

Web Design
90 5768 018 1 Web Design Index 1
90 5768 026 2 Web Design Index 2
90 5768 045 9 Web Design Index 3
90 5768 063 7 Web Design Index 4

Folding & Packaging
90 5768 039 4 How To Fold
90 5768 040 8 Folding Patterns
 for Display & Publicity
90 5768 044 0 Structural Package Designs
90 5768 053 x Mail It!
90 5768 054 8 Special Packaging

More titles in preparation
In addition to the Agile Rabbit series of book+CD-ROM sets,
The Pepin Press publishes a wide range of books on art, design,
architecture, applied art, and popular culture.

Please visit www.pepinpress.com for more information.

Contents

Copyright © 2003 Pepin van Roojen

The Pepin Press BV
P.O. Box 10349
1001 EH Amsterdam, The Netherlands

Tel +31 20 4202021
Fax +31 20 4201152
mail@pepinpress.com
www.pepinpress.com
www.agilerabbit.com

Concept and Photography: Günter Beer
Layout: Kathi Günter and Sarah David-Spickermann
Cover design and book master: Pepin van Roojen

Thanks to Annette Abstoss, Fruits Guzman, Barcelona

ISBN 90 5768 048 3
The Pepin Press / Agile Rabbit editions
Series editor: Pepin van Roojen

10 9 8 7 6 5 4 3 2
2005 04 03

Manufactured in Singapore

English

This book contains images for use as a graphic resource, or inspiration. All the illustrations are stored in high-resolution format on the enclosed free CD-ROM (Mac and Windows) and are ready to use for professional quality printed media and web page design. The pictures can also be used to produce postcards, either on paper or digitally, or to decorate your letters, flyers, etc.
They can be imported directly from the CD into most design, image-manipulation, illustration, word-processing and e-mail programs; no installation is required. Some programs will allow you to access the images directly; in others, you will first have to create a document, and then import the images. Please consult your software manual for instructions.
The CD-ROM comes free with this book, but is not for sale separately. The publishers do not accept any responsibility should the CD not be compatible with your system. For non-professional applications, single images can be used free of charge. The images cannot be used for any type of commercial or otherwise professional application – including all types of printed or digital publications – without prior permission from The Pepin Press/Agile Rabbit Editions.

For inquiries about permissions and fees:
mail@pepinpress.com
Fax +31 20 4201152

Español

En este libro podrá encontrar imágenes que le servirán como fuente de material gráfico o como inspiración para realizar sus propios diseños. Se adjunta un CD-ROM gratuito (Mac y Windows) donde hallará todas las ilustraciones en un formato de alta resolución, con las que podrá conseguir una impresión de calidad profesional y diseñar páginas web. Las imágenes pueden también emplearse para realizar postales, de papel o digitales, o para decorar cartas, folletos, etc.
Estas imágenes se pueden importar desde el CD a la mayoría de programas de diseño, manipulación de imágenes, dibujo, tratamiento de textos y correo electrónico, sin necesidad de utilizar un programa de instalación. Algunos programas le permitirán acceder a las imágenes directamente; otros, sin embargo, requieren la creación previa de un documento para importar las imágenes. Consulte su manual de software en caso de duda.
El CD-ROM se ofrece de manera gratuita con este libro, pero está prohibida su venta por separado. Los editores no asumen ninguna responsabilidad en el caso de que el CD no sea compatible con su sistema.
Se autoriza el uso de estas imágenes de manera gratuita para aplicaciones no profesionales. No se podrán emplear en aplicaciones de tipo profesional o comercial (incluido cualquier tipo de publicación impresa o digital) sin la autorización previa de The Pepin Press/Agile Rabbit Editions.

Para más información acerca de autorizaciones y tarifas:
mail@pepinpress.com
Fax +31 20 4201152

Português

Este livro contém imagens que podem ser utilizadas como fonte de material gráfico ou como inspiração para realizar os seus próprios desenhos. Você encontrará todas as ilustrações em formato de alta resolução dentro do CD-ROM gratuito (Mac e Windows), e com elas poderá conseguir uma impressão de qualidade profissional e desenhar páginas web. As imagens também podem ser usadas para criar postais, de papel ou digitais, ou para decorar cartas, folhetos, etc.

Estas imagens podem ser importadas do CD para a maioria de programas de desenho, manipulação de imagem, ilustração, processamento de texto e correio eletrônico, sem a necessidade de utilizar um programa de instalação. Alguns programas permitirão que você tenha acesso às imagens diretamente; e em outros, você deverá criar um documento antes de importar as imagens. Por favor, consulte o seu manual de software para obter maiores informações.

O CD-ROM é oferecido de forma gratuita com este livro, porém é proibido vendê-lo separadamente. Os editores não assumem nenhuma responsabilidade no caso de que o CD não seja compatível com o seu sistema.

Desde que não seja para aplicação profissional, as imagens individuais podem ser utilizadas gratuitamente. As imagens não podem ser empregadas em nenhum tipo de aplicação comercial ou profissional - incluindo todos os tipos de publicações impressas ou digitais - sem a prévia permissão de The Pepin Press/Agile Rabbit Editions.

Para esclarecer dúvidas a respeito das permissões e taxas:
mail@pepinpress.com
Fax +31 20 4201152

Français

Cet ouvrage renferme des illustrations destinées à servir de ressources graphiques ou d'inspiration. La totalité des images sont stockées en format haute définition sur le CD-ROM gratuit inclus (Mac et Windows), prêtes à l'emploi en vue de réaliser des impressions ou pages Web de qualité professionnelle. Elles permettent également de créer des cartes postales, aussi bien sur papier que virtuelles, ou d'agrémenter vos courriers, prospectus et autres.

Vous pouvez les importer directement à partir du CD dans la plupart des applications de création, manipulation graphique, illustration, traitement de texte et messagerie, sans qu'aucune installation ne soit nécessaire. Certaines applications permettent d'accéder directement aux images, tandis que dans d'autres, vous devez d'abord créer un document, puis importer les images. Veuillez consultez les instructions dans le manuel du logiciel concerné.

Le CD-ROM est fourni gratuitement avec le livre, mais il ne peut être vendu séparément. L'éditeur décline toute responsabilité si ce CD n'est pas compatible avec votre ordinateur.

Vous pouvez utiliser les images individuelles sans frais dans des applications non-professionnelles. Il est interdit d'utiliser les images avec des applications de type professionnel ou commercial (y compris toutes les sortes de publications numériques ou imprimés) sans l'autorisation préalable de The Pepin Press/Agile Rabbit Editions.

Pour tout renseignement relatif aux autorisations et aux frais d'utilisation:
mail@pepinpress.com
Fax +31 20 4201152

Italiano

Questo libro contiene immagini che possono essere utilizzate come risorsa grafica o come fonte di ispirazione. Tutte le illustrazioni sono contenute nell'allegato CD-ROM gratuito (per Mac e Windows), in formato ad alta risoluzione e pronte per essere utilizzate per pubblicazioni professionali e pagine web. Possono essere inoltre usate per creare cartoline, su carta o digitali, o per abbellire lettere, opuscoli, ecc.

Dal CD, le immagini possono essere importate direttamente nella maggior parte dei programmi di grafica, di ritocco, di illustrazione, di scrittura e di posta elettronica; non è richiesto alcun tipo di installazione. Alcuni programmi vi consentiranno di accedere alle immagini direttamente; in altri, invece, dovrete prima creare un documento e poi importare le immagini. Consultate il manuale del software per maggiori informazioni.

Il CD-ROM è allegato gratuitamente al libro e non può essere venduto separatamente. L'editore non può essere ritenuto responsabile qualora il CD non fosse compatibile con il sistema posseduto.

Per applicazioni di tipo non professionale, le singole immagini possono essere utilizzate gratuitamente. Se desiderate, invece, utilizzare le immagini per applicazioni di tipo professionale o con scopi commerciali, comprese tutte le pubblicazioni digitali o stampate, sarà necessaria la relativa autorizzazione da parte della casa editrice The Pepin Press/Agile Rabbit Editions.

Per ulteriori informazioni su autorizzazioni e canoni per il diritto di sfruttamento commerciale rivolgetevi a:
mail@pepinpress.com
Fax +31 20 4201152

Deutsch

Dieses Buch enthält Bilder, die als Ausgangsmaterial für graphische Zwecke oder als Anregung genutzt werden können. Alle Abbildungen sind in hoher Auflösung auf der beiliegenden Gratis-CD-ROM (für Mac und Windows) gespeichert und lassen sich direkt zum Drucken in professioneller Qualität oder zur Gestaltung von Websites einsetzen. Sie können sie auch als Motive für Postkarten auf Karton oder in digitaler Form, oder als Ausschmückung für Ihre Briefe, Flyer etc. verwenden.
Die Bilder lassen sich direkt in die meisten Zeichen-, Bildbearbeitungs-, Illustrations-, Textverarbeitungs- und E-Mail-Programme laden, ohne dass zusätzliche Programme installiert werden müssen. In einigen Programmen können die Dokumente direkt geladen werden, in anderen müssen Sie zuerst ein Dokument anlegen und können dann die Datei importieren. Genauere Hinweise dazu finden Sie im Handbuch zu Ihrer Software.
Die CD-ROM wird kostenlos mit dem Buch geliefert und ist nicht separat verkäuflich. Der Verlag haftet nicht für Inkompatibilität der CD-ROM mit Ihrem System.
Für nicht professionelle Anwendungen können einzelne Bilder kostenfrei genutzt werden. Die Bilder dürfen ohne vorherige Genehmigung von The Pepin Press /Agile Rabbit Editions nicht für kommerzielle oder sonstige professionelle Anwendungen einschließlich aller Arten von gedruckten oder digitalen Medien eingesetzt werden.

Für Fragen zu Genehmigungen und Preisen wenden Sie sich bitte an:
mail@pepinpress.com
Fax +31 20 4201152

日本語

本書にはグラフィック リソースやインスピレーションとして使用できる美しいイメージ画像が含まれています。すべてのイラストレーションは、無料の付属 CD-ROM (Mac および Windows 用) に高解像度で保存されており、これらを利用してプロ品質の印刷物や WEB ページを簡単に作成することができます。また、紙ベースまたはデジタルの葉書の作成やレター、ちらしの装飾等に使用することもできます。

これらの画像は、CD から主なデザイン、画像処理、イラスト、ワープロ、E メールソフトウェアに直接取り込むことができます。インストレーションは必要ありません。プログラムによっては、画像に直接アクセスできる場合や、一旦ドキュメントを作成した後に画像を取り込む場合等があります。詳細は、ご使用のソフトウェアのマニュアルをご参照下さい。

CD-ROM 上のファイル名は、本書のページ数に対応しています。ページに複数の画像が含まれる場合は、左から右、上から下の順番で番号がつけられ、ページ番号に続く数字または下記のレターコードで識別されます。

T =トップ (上部)、B= ボトム (下部)、C =センター (中央)、L= レフト (左) R =ライト (右)

CD-ROM は本書の付属品であり、別売されておりません。CD がお客様のシステムと互換でなかった場合、発行者は責任を負わないことをご了承下さい。

プロ用以外のアプリケーションで、画像を一回のみ無料で使用することができます。The Pepin Press / Agile Rabbit Editions から事前許可を得ることなく、あらゆる形体の印刷物、デジタル出版物をはじめとする、あらゆる種類の商業用ならびにプロ用アプリケーションで画像を使用することを禁止します。

使用許可と料金については、下記までお問い合わせ下さい。

mail@pepinpress.com

ファックス： +31 20 4201152

中 文

本書包含精美圖片，可以作為圖片資源或激發靈感的資料使用。這些圖片存儲在所附的高清晰度免費 CD-ROM (可在 Mac 和 Windows 下使用) 中，可用於專業的高品質印刷媒體和網頁設計。圖片還可以用於製作紙質和數字明信片，或裝飾您的信封、傳單等。您無需安裝即可以把圖片直接從 CD 調入大多數的設計、圖像處理、圖片、文字處理和電子郵件程序。有些程序允許您直接使用圖片；另外一些，您則需要先創建一個文件，然後引入圖片。用法說明請參閱軟體說明書。

在 CD 中的文件名稱是與書中的頁碼相對應的。如果書頁中的圖片超過一幅，其順序為從左到右，從上到下。這會在書頁號後加一個數字來表示，或者是加一個字母：T = 上， B = 下，C = 中， L = 左， R = 右。

本書附帶的 CD-ROM 是免費的，但 CD-ROM 不單獨出售。如果 CD 與您的系統不相容，出版商不承擔任何責任。

就非專業的用途而言，可以免費使用單個圖片。若未事先得到 The Pepin Press/Agile Rabbit Editions 的許可，不得將圖片用於任何其他類型的商業或專業用途 - 包括所有類型的印刷或數字出版物。

有關許可及收費的詢問，請查詢：

Mail@pepinpress.com

傳真： +31 20 4201152

 14

 32

 52

 70

 96

 178

 206

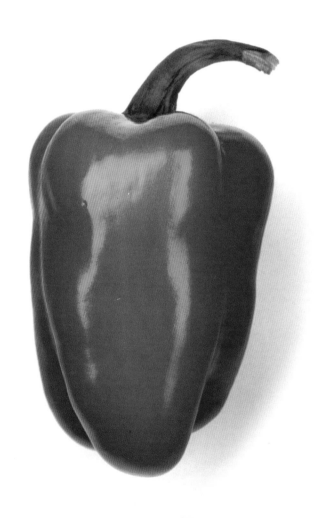

16–1

RED BELL PEPPER
PIMIENTO ROJO
ROTER PAPRIKA
POIVRON ROUGE
PEPERONE ROSSO

17–1

PLUM TOMATO
TOMATE DE PERA
BIRNENTOMATE
TOMATE POIRE
POMODORO TIPO SAN MARZANO

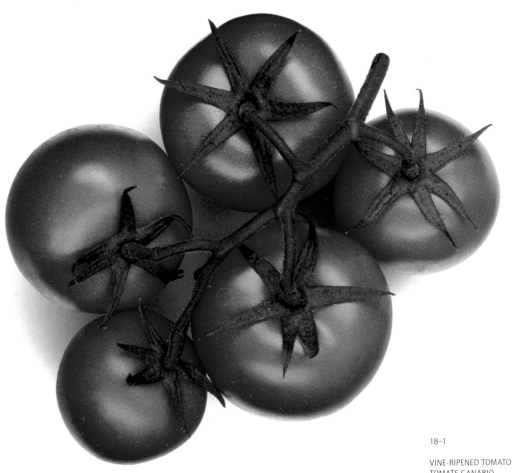

18-1

VINE-RIPENED TOMATO
TOMATE CANARIO
STRAUCHTOMATE
TOMATE CANARIENNE
POMODORO CANARIE

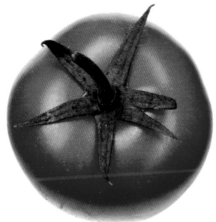

19-1

19-2

19-1

VINE-RIPENED TOMATO
TOMATE CANARIO
STRAUCHTOMATE
TOMATE CANARIENNE
POMODORO CANARIE

19-2

SUN-DRIED TOMATO
TOMATE DESECADO
GETROCKNETE TOMATE
TOMATES SÉCHÉE
POMODORI SECCHO

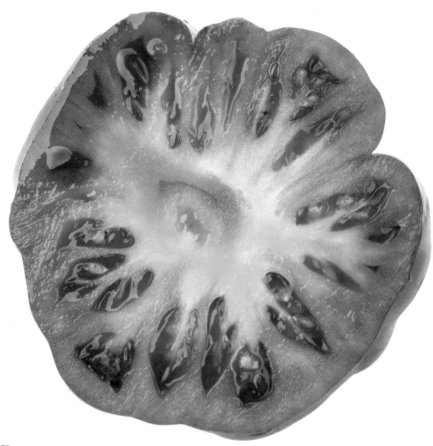

20-1

RAF TOMATO
TOMATE RAF
RAF-TOMATE
TOMATE RAF
POMODORO TIPO RAF

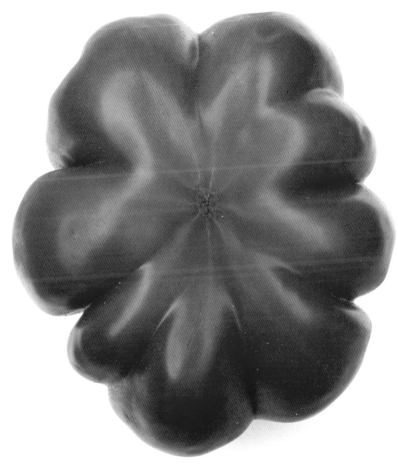

21-1

RAF TOMATO
TOMATE RAF
RAF-TOMATE
TOMATE RAF
POMODORO TIPO RAF

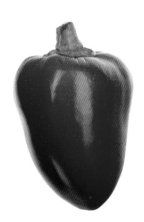

22-2

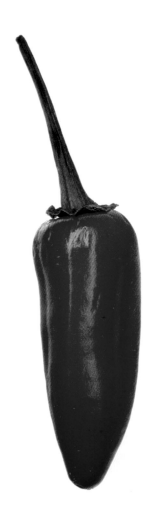

22-1

22-1

RED JALAPEÑO PEPPER
CHILE JALAPEÑO ROJO
ROTE JALAPEÑO
PIMENT JALAPEÑO
PEPERONCINO TIPO JALAPEÑO

22-2

BABY RED BELL PEPPER
PIMIENTO ROJO MINI
ROTER MINI-PAPRIKA
PIMENT CERISE
PEPERONCINO ROSSO

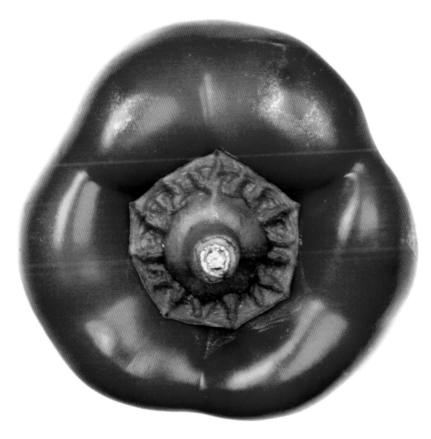

23–1

BABY RED BELL PEPPER
PIMIENTO ROJO MINI
ROTER MINI-PAPRIKA
PIMENT CERISE
PEPERONCINO ROSSO

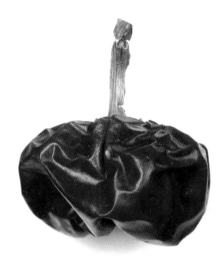

24-2

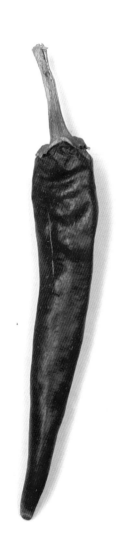

24-1

24-1	24-2
RED CHILLI PEPPER	ÑORA DRIED CHILLI PEPPER
CHILE ROJO	PIMIENTO ÑORA
ROTE CHILISCHOTE	GETROCKNETE CHILISCHOTE
PIMENT ROUGE	PIMENT ÑORA
PEPERONCINO	PEPERONCINO TONDO SECCO

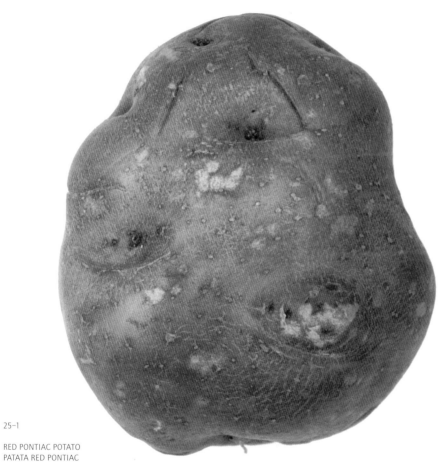

25-1

RED PONTIAC POTATO
PATATA RED PONTIAC
RED PONTIAC-KARTOFFEL
POMME DE TERRE RED PONTIAC
PATATA DOLCE

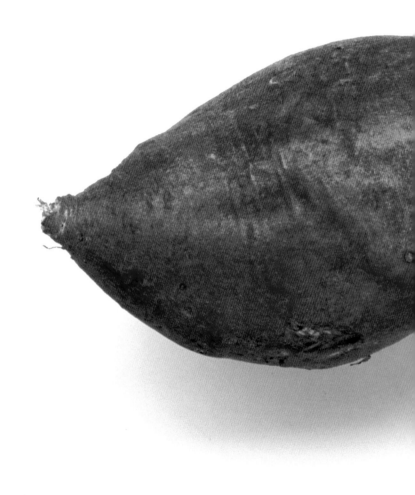

26–1

SWEET POTATO
BONIATO
SÜßKARTOFFEL
PATATE DOUCE
PATATA AMERÍ-

28–1

PINK RADISH
RABANITO ROSADO
ROSA RADIESCHEN
RADIS ROSE
RAVANELLO ROSA

29-1

29-2

29-1	29-2
SCARLET ROUND RADISHES	PINK RADISH
RABANITOS REDONDO ESCARLATA	RABANITO ROSADO
RUNDE RADIESCHEN	ROSA RADIESCHEN
RADIS RONDS ÉCARLATES	RADIS ROSE
RAVANELLI TONDI ROSSI	RAVANELLO ROSA

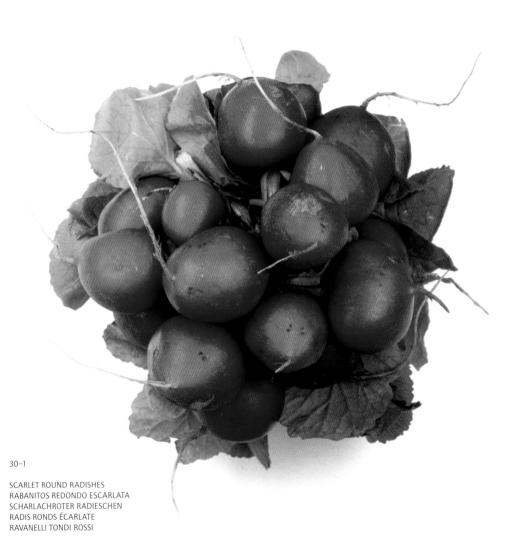

30–1

SCARLET ROUND RADISHES
RABANITOS REDONDO ESCARLATA
SCHARLACHROTER RADIESCHEN
RADIS RONDS ÉCARLATE
RAVANELLI TONDI ROSSI

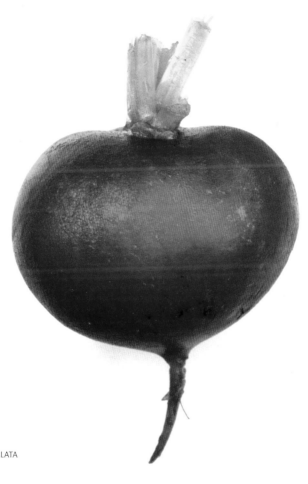

31-1
SCARLET ROUND RADISH
RABANITO REDONDO ESCARLATA
RUNDES RADIESCHEN
RADIS ROND ÉCARLATE
RAVANELLO TONDO ROSSO

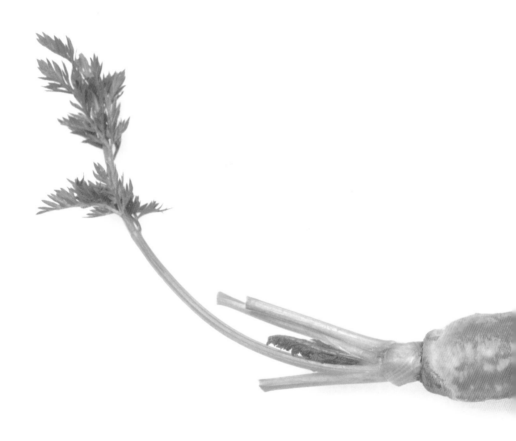

34-1

BABY CARROT
ZANAHORIA MINI
JUNGE KAROTTE
JEUNE CAROTTE
CAROTA TENERA

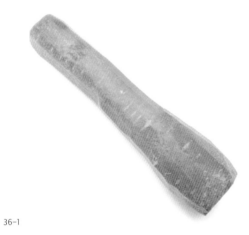

36-1

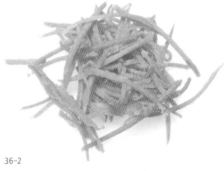

36-2

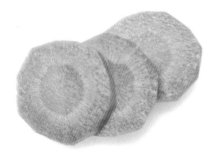

36-3

36-1	36-2	36-3
CARROT	CARROT	CARROT
ZANAHORIA	ZANAHORIA	ZANAHORIA
KAROTTE	KAROTTE	KAROTTE
CAROTTE	CAROTTE	CAROTTE
CAROTA	CAROTA	CAROTA

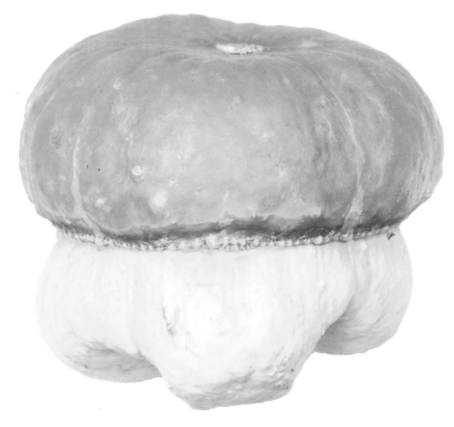

37-1

TURBAN SQUASH
CALABAZA TURBANTE DE MORO
TURBAN-KÜRBIS
COURGE TURBAN
ZUCCA A TURBANTE

38-2

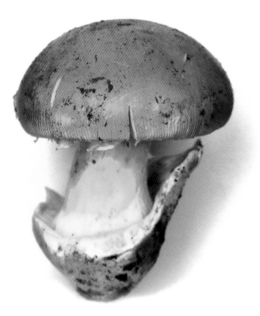

38-1

38-1

ROYAL AGARIC
ORONJA
KAISERLING
AMANITE DES CÉSARS
OVOLO BUONO

38-2

ROYAL AGARIC
ORONJA
KAISERLING
AMANITE DES CÉSARS
OVOLO BUONO

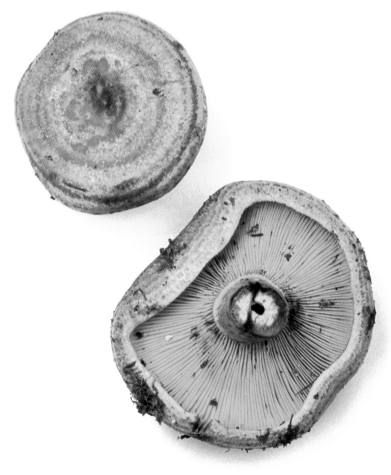

39-1

MILK CAPS
NÍSCALOS
ECHTE REIZKER
LACTAIRES DÉLICIEUX
LATTARI

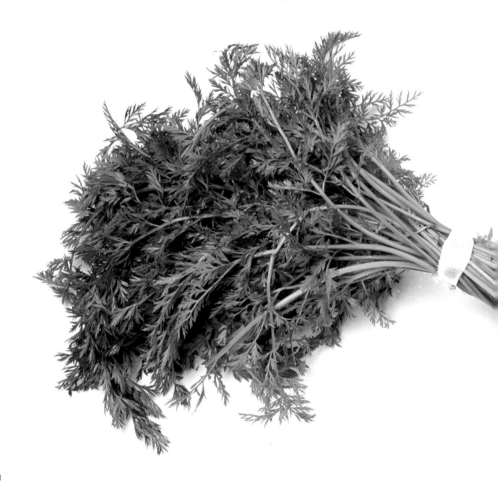

40-1

CARROTS
ZANAHORIAS
KAROTTEN
CAROTTES
CAROTE

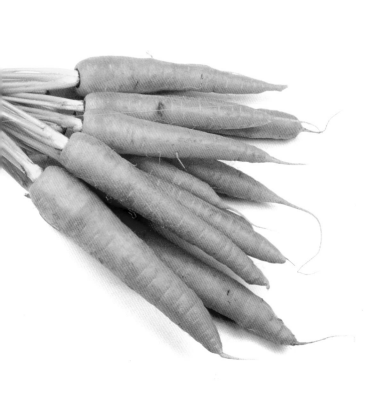

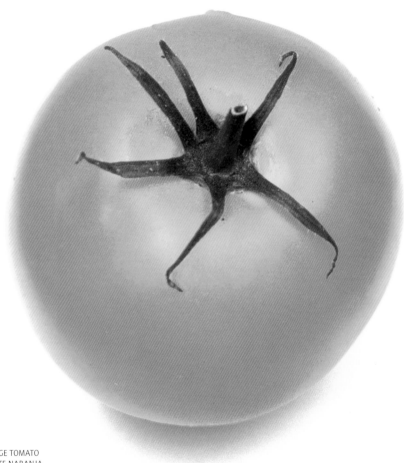

42-1

ORANGE TOMATO
TOMATE NARANJA
ORANGE TOMATE
TOMATE ORANGE
POMODORO ARAN-

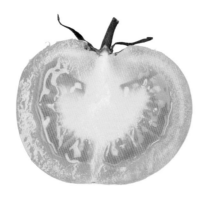

43-1

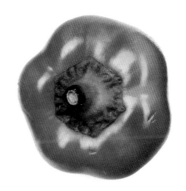

43-2

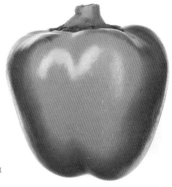

43-3

43-1	43-2	43-3
ORANGE TOMATO	BABY RED BELL PEPPER	BABY RED BELL PEPPER
TOMATE NARANJA	PIMIENTO ROJO MINI	PIMIENTO ROJO MINI
ORANGE TOMATE	ROTER MINI-PAPRIKA	ROTER MINI-PAPRIKA
TOMATE ORANGE	PIMENT CERISE	PIMENT CERISE
POMODORO ARANCIONE	PEPERONCINO ROSSO	PEPERONCINO ROSSO

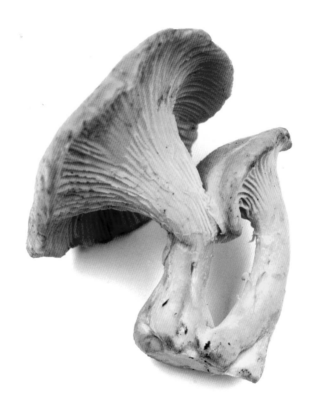

44-1

CHANTERELLE
REBOZUELO
PFIFFERLING
CHANTERELLE
FUNGO GALLINAC-

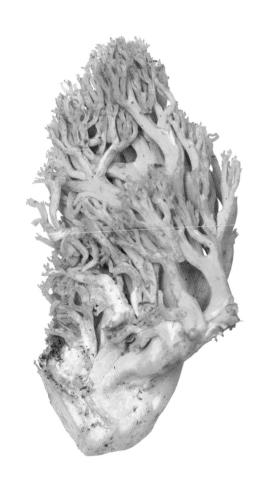

45–1

GOLDEN CLAVARIA
CLAVARIA
GOLDGELBER ZIEGENBART
CLAVAIRE DORÉ
DITOLA

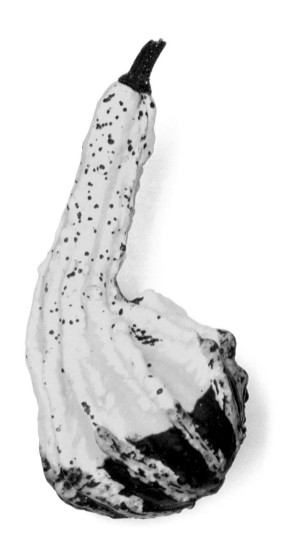

46-1

ORNAMENTAL SQUASH
CALABAZA DECORATIVA
ZIERKÜRBIS
COURGE DÉCORATIVE
ZUCCA ORNAMENTALE

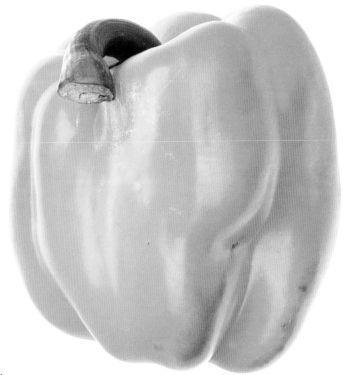

47–1

YELLOW BELL PEPPER
PIMIENTO AMARILLO
GELBER PAPRIKA
POIVRON JAUNE
PEPERONE GIALLO

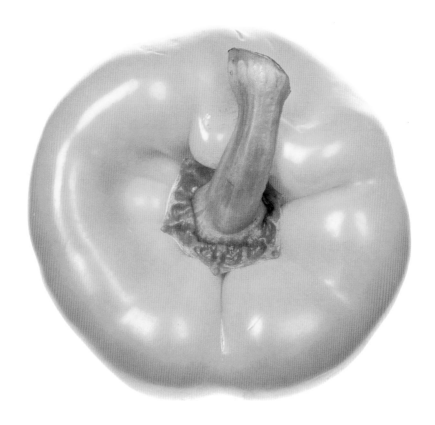

48–1

YELLOW BELL PEPPER
PIMIENTO AMARILLO
GELBER PAPRIKA
POIVRON JAUNE
PEPERONE GIALLO

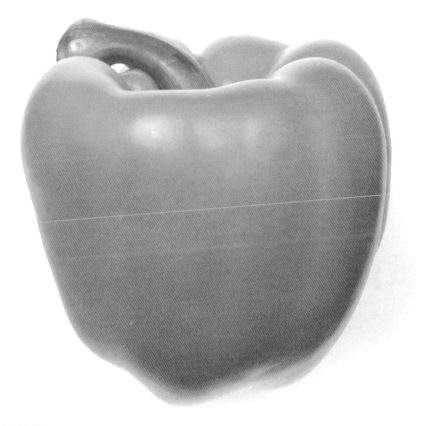

49–1

YELLOW BELL PEPPER
PIMIENTO AMARILLO
GELBER PAPRIKA
POIVRON JAUNE
PEPERONE GIALLO

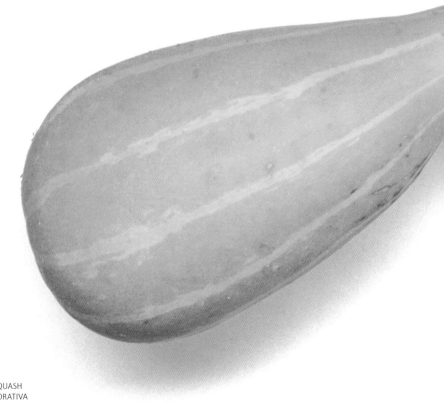

50–1

ORNAMENTAL SQUASH
CALABAZA DECORATIVA
ZIERKÜRBIS
COURGE DÉCORATIVE
ZUCCA ORNAMENTALE

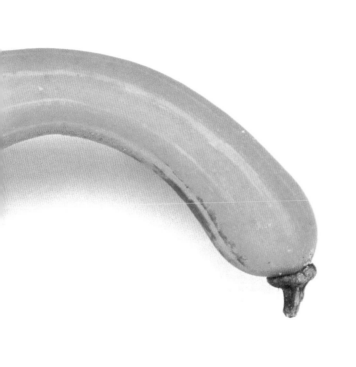

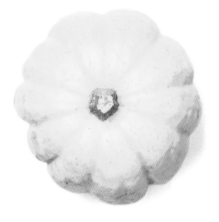

54-1

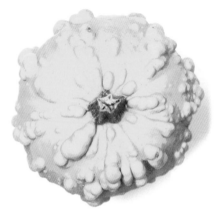

54-2

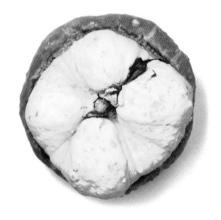

54-3

54-1 54-2

ORNAMENTAL SQUASH
CALABAZA DECORATIVA
ZIERKÜRBIS
COURGE DÉCORATIVE
ZUCCA ORNAMENTALE

54-3

TURBAN SQUASH
CALABAZA TURBANTE
TURBAN-KÜRBIS
COURGE TURBAN
ZUCCA A TURBANTE

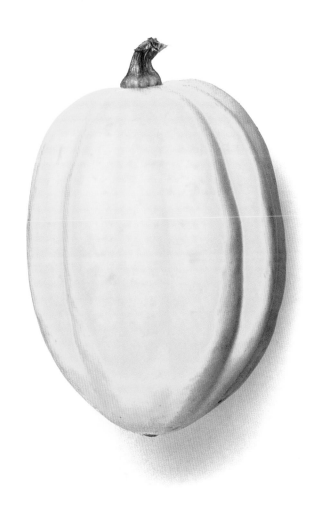

55-1

ORNAMENTAL SQUASH
CALABAZA DECORATIVA
ZIERKÜRBIS
COURGE DÉCORATIVE
ZUCCA ORNAMENTALE

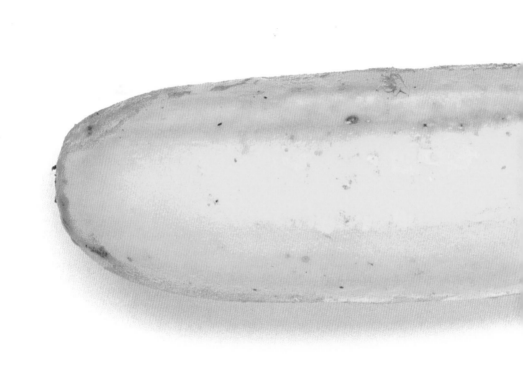

56-1

YELLOW COURGETTE
CALABACÍN AMARILLO
GELBER ZUCCHINO
COURGETTE JAUNE
ZUCCHINO GIALLO

58-2

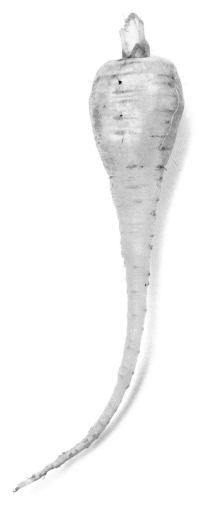

58-1

58-1	58-2
PARSNIP	DANDELION GREENS
CHIRIVÍA	DIENTE DE LEÓN
PASTINAKE	LÖWENZAHNGRÜN
PANAIS	DENT-DE-LION (PISSENLIT)
PASTINACA	DENTE DI LEONE

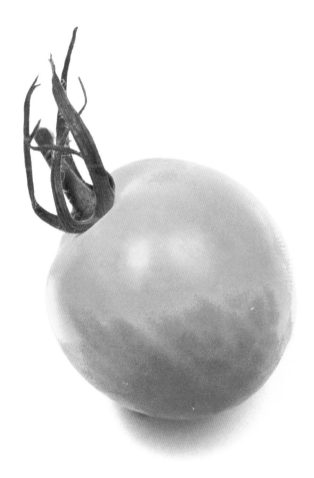

59-1

YELLOW CHERRY TOMATO
TOMATE CHERRY AMARILLO
GELBE KIRSCHTOMATE
TOMATE CERISE JAUNE
POMODORINI CILIEGIA GIALLI

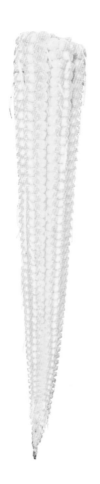

60-1

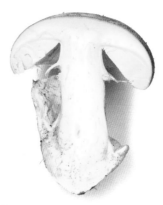

60-2

60-1

60-2

BABY CORN
MAÍZ DULCE MINI
JUNGER MAIS
MAÏS MINIATURE
PANNOCCHIETTA

ROYAL AGARIC
ORONJA
KAISERLING
AMANITE DES CÉSARS
OVOLO BUONO

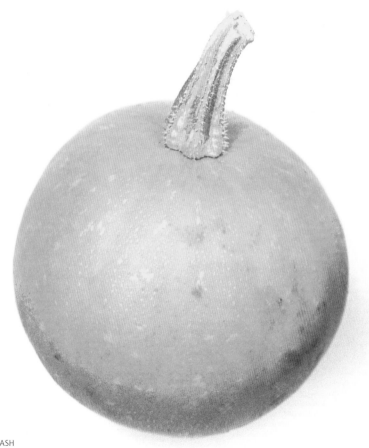

61-1

ORNAMENTAL SQUASH
CALABAZA DECORATIVA
ZIERKÜRBIS
COURGE DÉCORATIVE
ZUCCA ORNAMENTALE

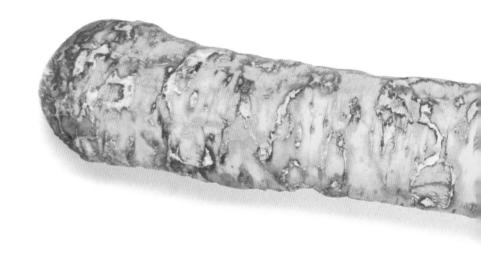

62–1

HORSERADISH
RÁBANO RUSTICANO
MEERRETTICH
RADIS DE CHEVAL
RAFANO RUSTICANO

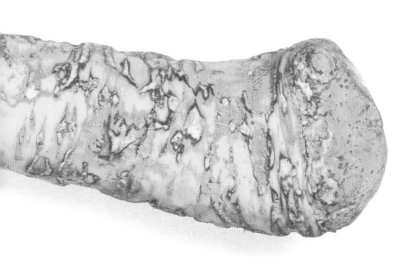

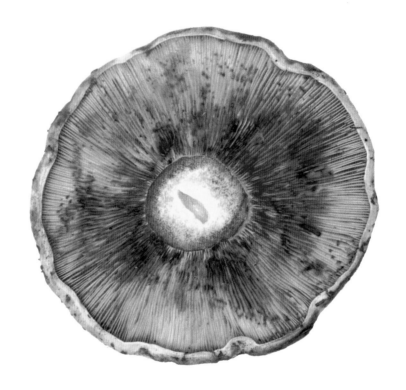

64–1

MILK CAP
NÍSCALO
ECHTER REIZKER
LACTAIRE DÉLICIEUX
LATTARIO

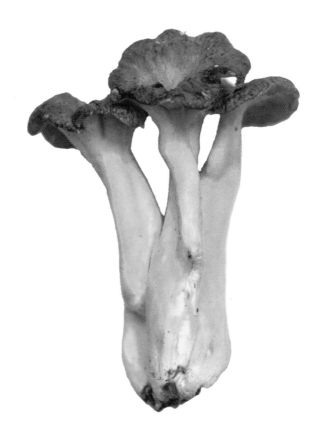

65–1

GOLDEN CHANTERELLE
REBOZUELO ANARANJADO
ECHTER PFIFFERLING
CHANTERELLE JAUNE
FUNGO GALLINACCIO

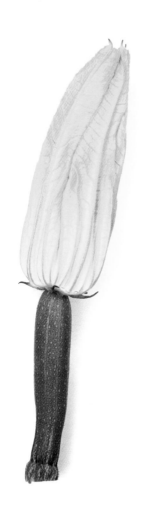

66-1

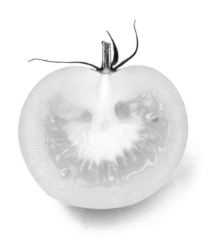

66-2

66-1

MINI COURGETTE WITH FLOWER
CALABACÍN MINI CON FLOR
MINI-ZUCCHINO MIT BLÜTE
JEUNE COURGETTE ET SA FLEUR
FIORE DI ZUCCHINO

66-2

YELLOW TOMATO
TOMATE AMARILLO
GELBE TOMATE
TOMATE JAUNE
POMODORO GIALLO

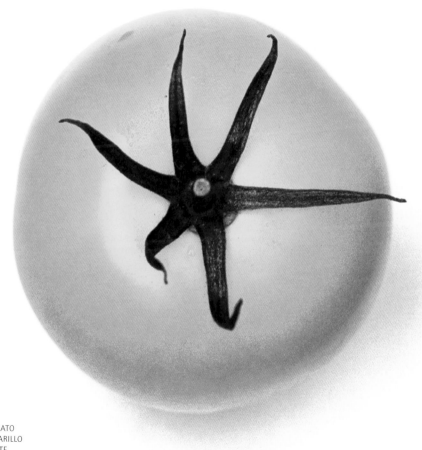

67–1

YELLOW TOMATO
TOMATE AMARILLO
GELBE TOMATE
TOMATE JAUNE
POMODORO GIALLO

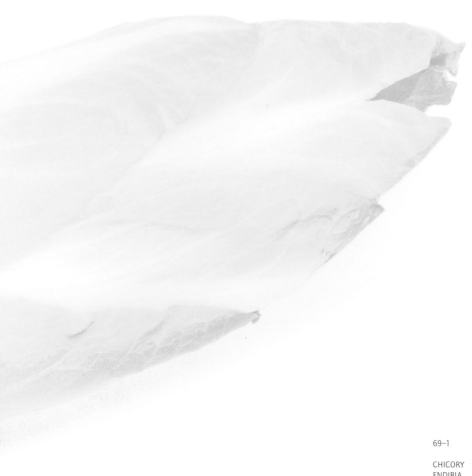

69-1

CHICORY
ENDIBIA
CHICORÉE
ENDIVE
INDIVIA BELGA

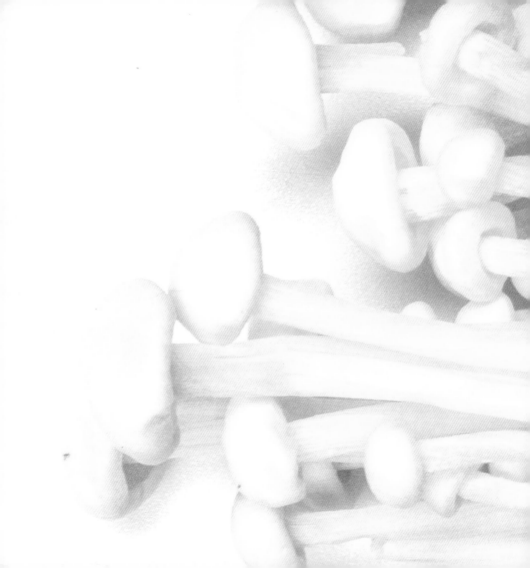

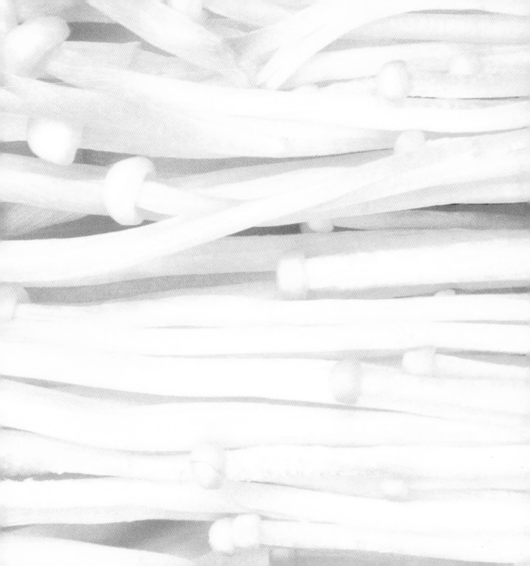

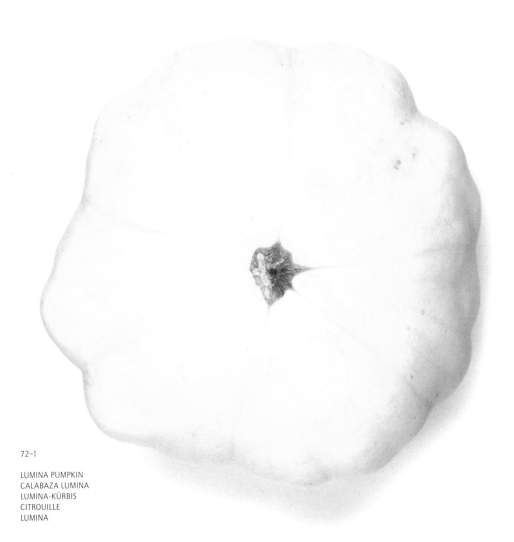

72-1

LUMINA PUMPKIN
CALABAZA LUMINA
LUMINA-KÜRBIS
CITROUILLE
LUMINA

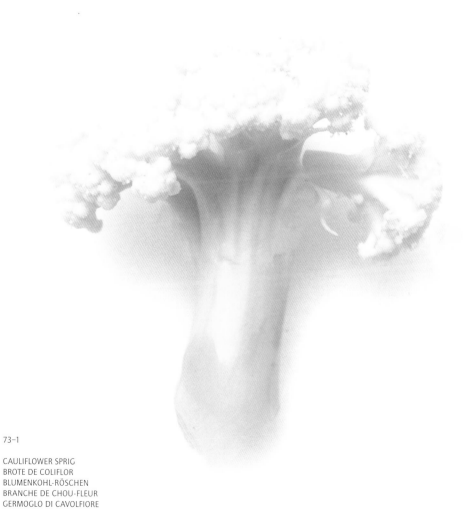

73-1

CAULIFLOWER SPRIG
BROTE DE COLIFLOR
BLUMENKOHL-RÖSCHEN
BRANCHE DE CHOU-FLEUR
GERMOGLO DI CAVOLFIORE

74–1

SWEET ONION
CEBOLLA DE FIGUERAS
SÜßE ZWIEBEL
OIGNON DE FIGUERAS
CIPOLLA TIPO FIGUERAS

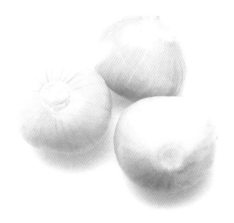

76-1

76-2

76-3

76-1 76-2	76-3
SWEET ONIONS	WHITE ONION
CEBOLLAS DE FIGUERAS	CEBOLLA BLANCA
SÜßE ZWIEBELN	WEIßE ZWIEBEL
OIGNONS DE FIGUERAS	OIGNON BLANC
CIPOLLE TIPO FIGUERAS	CIPOLLA BIANCA

77-1

WHITE ONION
CEBOLLA BLANCA
WEIßE ZWIEBEL
OIGNON BLANC
CIPOLLA BIANCA

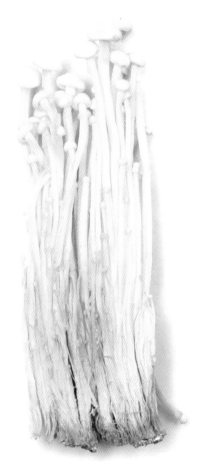

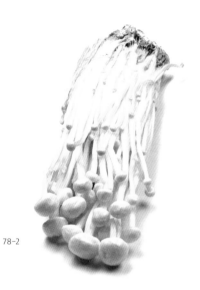

78-2

78-1

78-1

ENOKI MUSHROOMS
ENOKITAKE
ENOKI-PILZE
ENOKITAKE
FUNGO DELL'OLMO

78-2

ENOKI MUSHROOMS
ENOKITAKE
ENOKI-PILZE
ENOKITAKE
FUNGO DELL'OLMO

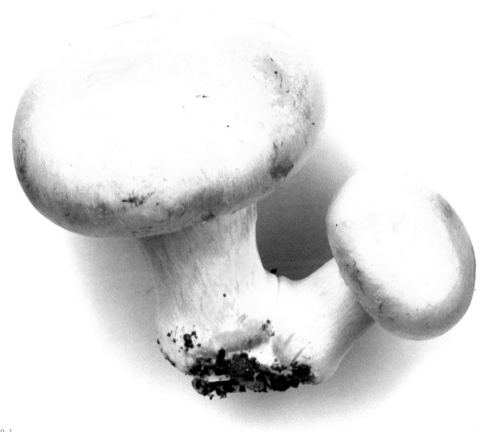

79-1

BUTTON MUSHROOM
CHAMPIÑÓN BOTÓN
KULTURCHAMPIGNON
CHAMPIGNON DE PARIS
CHAMPIGNON

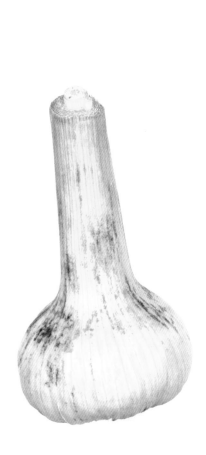

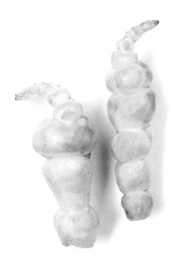

80-2

80-1

80-1	80-2
GARLIC	CHINESE ARTICHOKES
AJO	CROSNES
KNOBLAUCH	CHINESISCHE ARTISCHOCKE
AIL	CROSNES
AGLIO	CARCIOFI CINESI

81–1

GARLIC
AJO
KNOBLAUCH
AIL
AGLIO

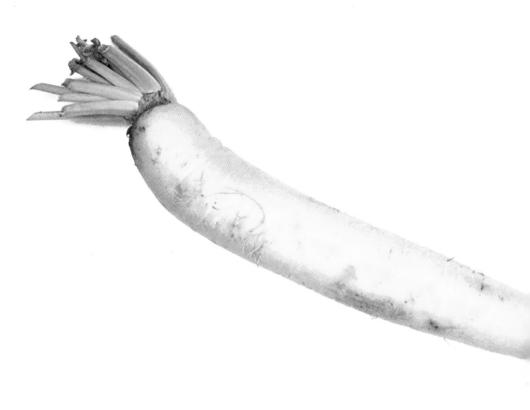

82-1

WHITE RADISH
RÁBANO BLANCO
WEIßER RETTICH
RAIFORT
RAPA

83-1

83-1

THISTLE
CARDO
DISTEL
CHARDON
CARDO

84-1

LETTUCE HEART
COGOLLO DE LECHUGA
SALATHERZ
CŒUR DE LAITUE
CUORE DI LATTUGA

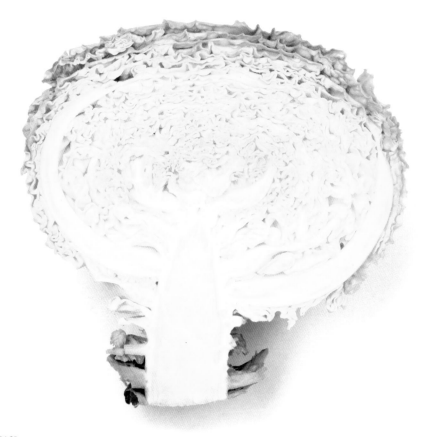

85–1

SAVOY CABBAGE
COL DE HOJA RIZADA
WIRSING
CHOU FRISÉ
CAVOLO A FOGLIA RICCIA

86-1

86-2

86-3

86-1	86-2	86-3
POTATO	POTATO	POTATO
PATATA	PATATA	PATATA
KARTOFFEL	KARTOFFEL	KARTOFFEL
POMME DE TERRE	POMME DE TERRE	POMME DE TERRE
PATATA	PATATA	PATATA

87-1

87-2

87-1 87-2 87-3

POTATO MONALISA POTATO
PATATA PATATA MONALISA
KARTOFFEL MONALISA-KARTOFFEL,
POMME DE TERRE POMME DE TERRE MONALISA
PATATA PATATA TIPO MONALISA

87-3

88–1

WHITE ASPARAGUS
ESPÁRRAGO BLANCO
WEIßER SPARGEL
ASPERGE BLANCHE
ASPARAGO BIANCO

90-1

90-2

90-3

90-1	90-2	90-3
COURGETTE	ESCAROLE LEAF	CUCUMBER
CALABACÍN	HOJA DE ESCAROLA	PEPINO
ZUCCHINI	WINTERENDIVIE	GURKE
COURGETTE	FEUILLE DE SCAROLE	CONCOMBRE
ZUCCHINO	FOGLIA DI SCAROLA	CETRIOLO

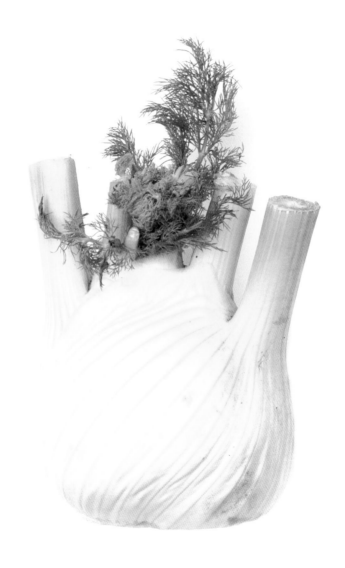

91–1

FENNEL BULB
BULBO DE HINOJO
FENCHELKNOLLE
BULBE DE FENOUIL
BULBO DI FINOCCHIO

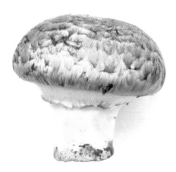

92-2

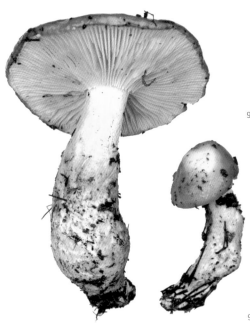

92-1

92-1	92-2
CHARCOAL BURNER	CREMINI MUSHROOM
CARBONERA	CHAMPIÑÓN DE BOSQUE
FRAUENTÄUBLING	WALDCHAMPIGNON
RUSSULE CHARBONNIÈRE	CHAMPIGNON DES BOIS
COLOMBINA	CHAMPIGNON

93-1

MEXICAN BREADFRUIT
MONSTERA
MONSTERA
MONSTERA
FRUTTA DEL MESSICO

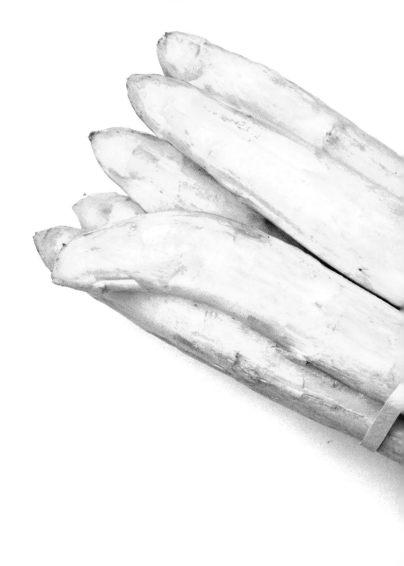

94-1

WHITE ASPARAGUS
ESPÁRRAGOS BLANCOS
WEIßER SPARGEL
ASPERGES BLANCHES
ASPARAGI BIANCHI

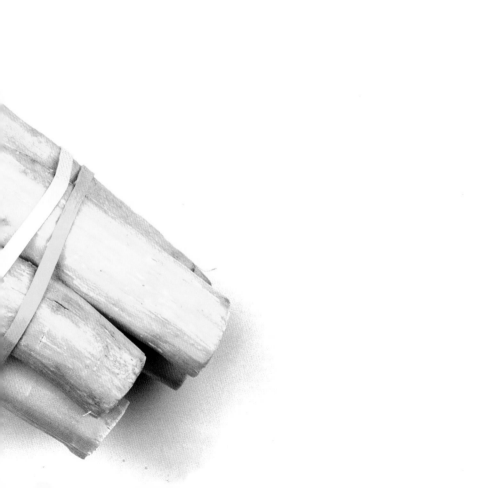

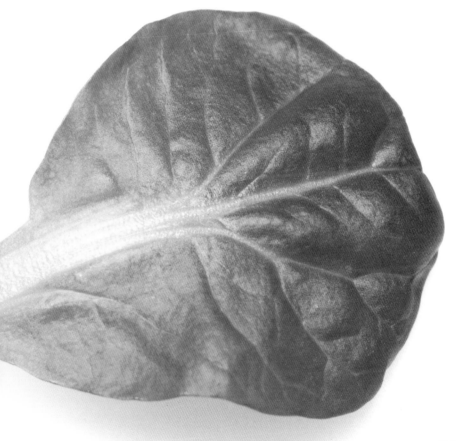

TATSOI
TATSOI
TATSOI
TATSOI
TATSOI

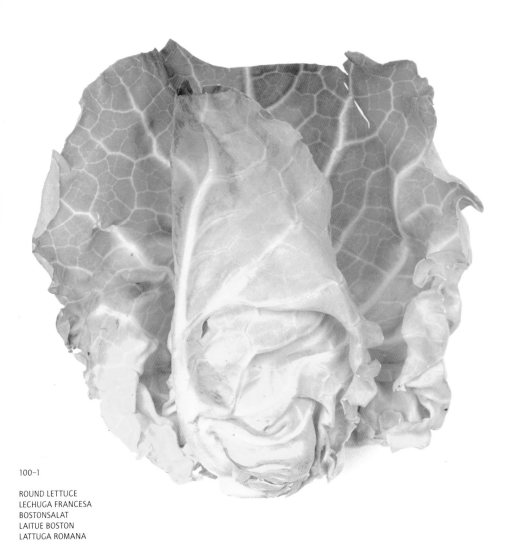

100–1

ROUND LETTUCE
LECHUGA FRANCESA
BOSTONSALAT
LAITUE BOSTON
LATTUGA ROMANA

101-1

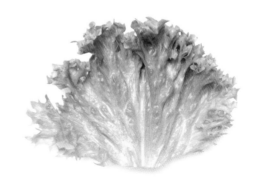

101-1	101-2
ROUND LETTUCE	LOLLO VERDE
LECHUGA FRANCESA	LOLLO VERDE
BOSTONSALAT	LOLLO VERDE
LAITUE BOSTON	LOLLO VERDE
LATTUGA ROMANA	LOLLO VERDE

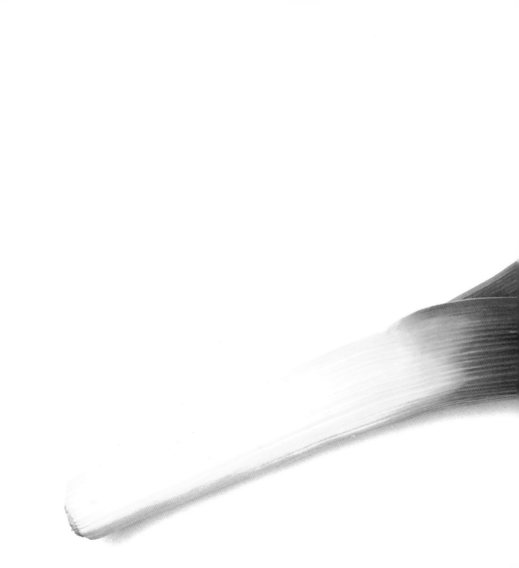

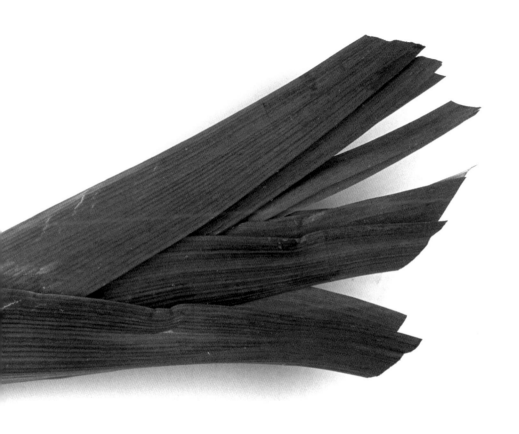

103-1

LEEK
PUERRO
PORREE
POIREAU
PORRO

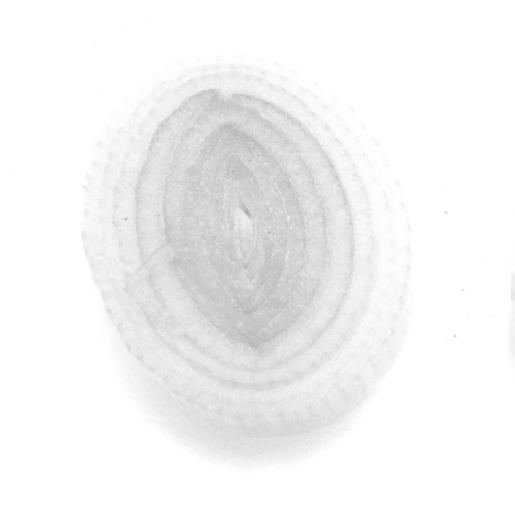

105-1

LEEK
PUERRO
PORREE
POIREAU
PORRO

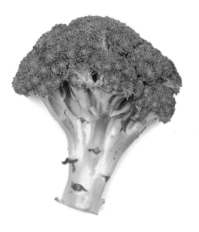

106-1

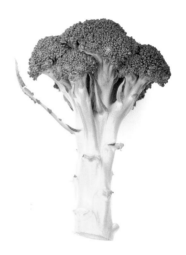

106-2

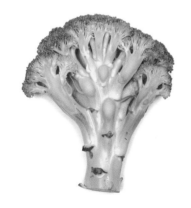

106-3

106-1	106-2	106-3
BROCCOLI	BROCCOLI	BROCCOLI
BRÉCOL	BRÉCOL	BRÉCOL
BROKKOLI	BROKKOLI	BROKKOLI
BROCOLI	BROCOLI	BROCOLI
BROCCOLI	BROCCOLI	BROCCOLI

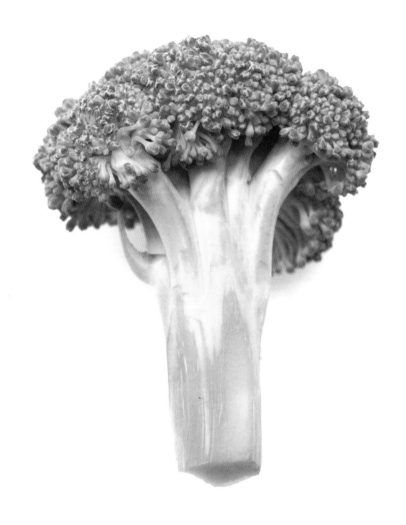

107-1

BROCCOLI
BRÉCOL
BROKKOLI
BROCOLI
BROCCOLI

108-1

GARLIC CHIVES
CEBOLLINO CHINO
KNOBLAUCHLAUCH
CIBOULETTE AIL
AGLIO CIPOLLINO

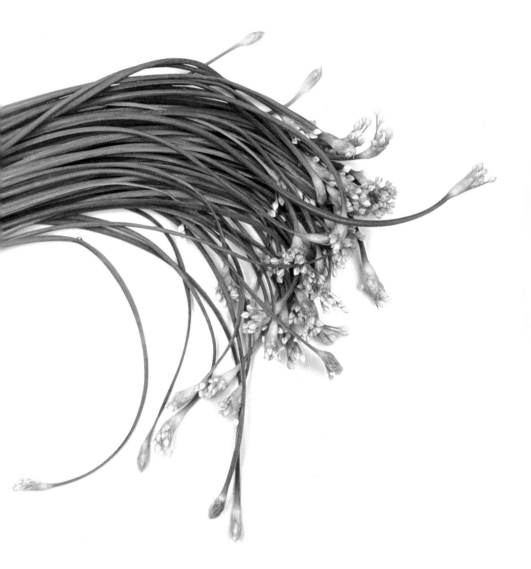

110-1

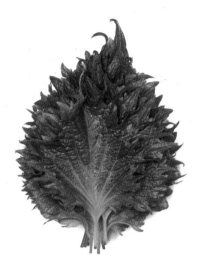

110-2

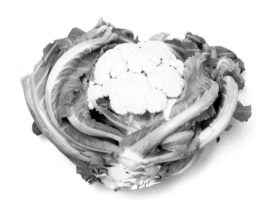

110-3

110-1	110-2	110-3
SPINACH SHOOTS	GREEN SISHO LEAF	CAULIFLOWER
BROTE DE ESPINACAS	HOJA DE SISHO VERDE	COLIFLOR
JUNGER SPINAT	SISHO-BLATT	BLUMENKOHL
POUSSES D'ÉPINARD	FEUILLE DE SISHO	CHOU-FLEUR
GERMOGLI DI SPINACI	FOGLIA DI SISHO VERDE	CAVOLFIORE

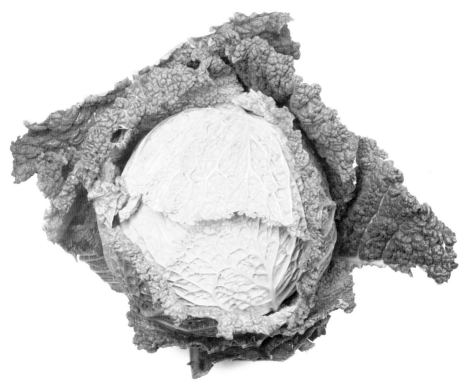

111-1

SAVOY CABBAGE
COL DE HOJA RIZADA
WIRSING
CHOU FRISÉ
CAVOLO A FOGLIA RICCIA

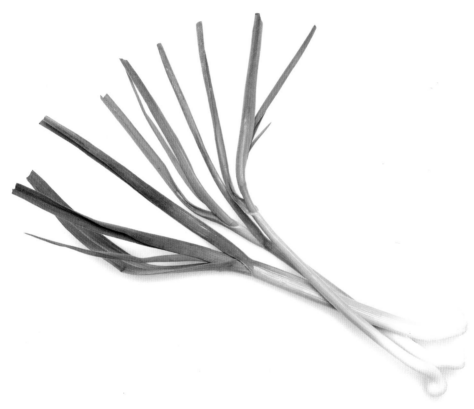

112–1

YOUNG GARLIC SHOOTS
AJOS TIERNOS
JUNGE KNOBLAUCHSPROSSEN
POUSSES D'AIL
ERBA AGLINA

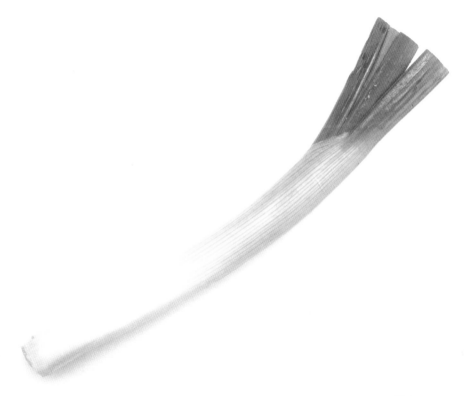

113–1

SPRING ONION
CEBOLLA TIERNA
FRÜHLINGSZWIEBEL
OIGNON VERT
CIPOLLA TENERA

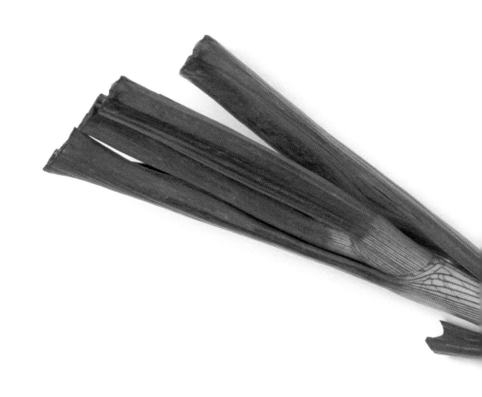

SPRING ONION
CEBOLLA TIERNA
FRÜHLINGSZWIEBEL
OIGNON VERT
CIPOLLA TENERA

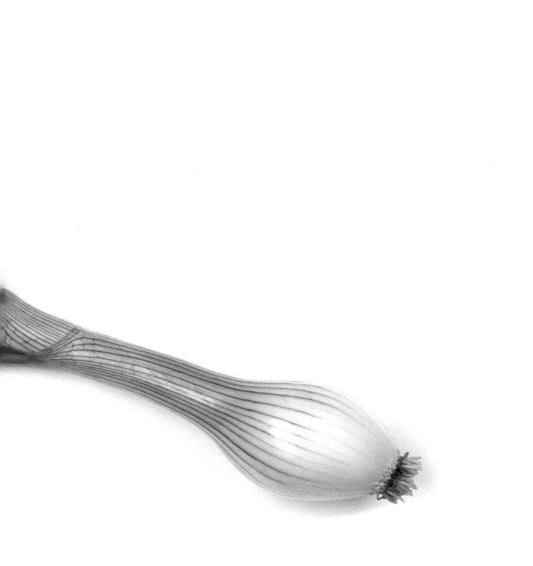

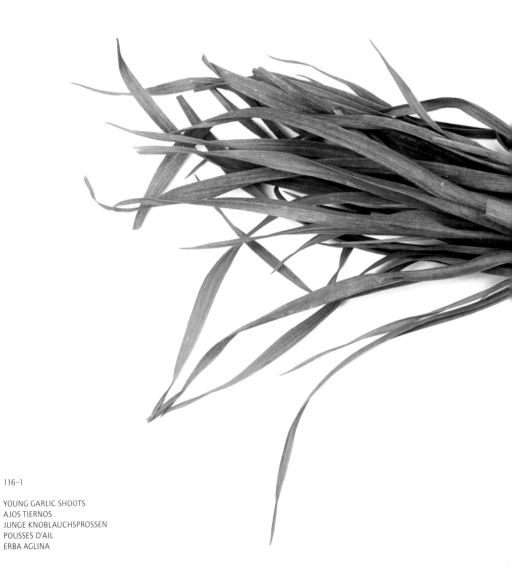

116–1

YOUNG GARLIC SHOOTS
AJOS TIERNOS
JUNGE KNOBLAUCHSPROSSEN
POUSSES D'AIL
ERBA AGLINA

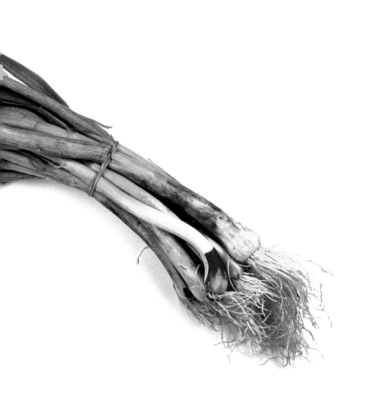

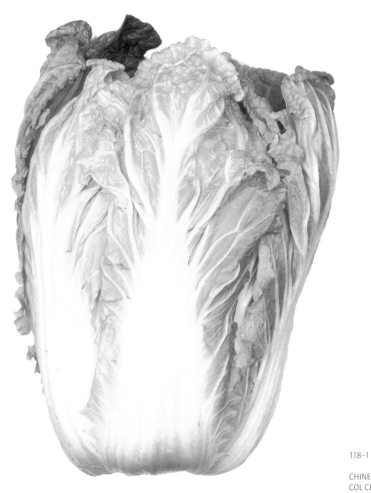

118-1

CHINESE CABBAGE
COL CHINA
CHINAKOHL
CHOU CHINOIS
CAVOLO CINESE

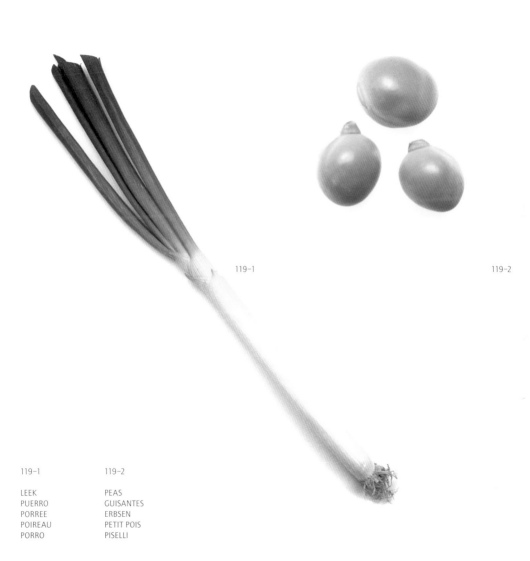

119-1

119-2

119-1

LEEK
PUERRO
PORREE
POIREAU
PORRO

119-2

PEAS
GUISANTES
ERBSEN
PETIT POIS
PISELLI

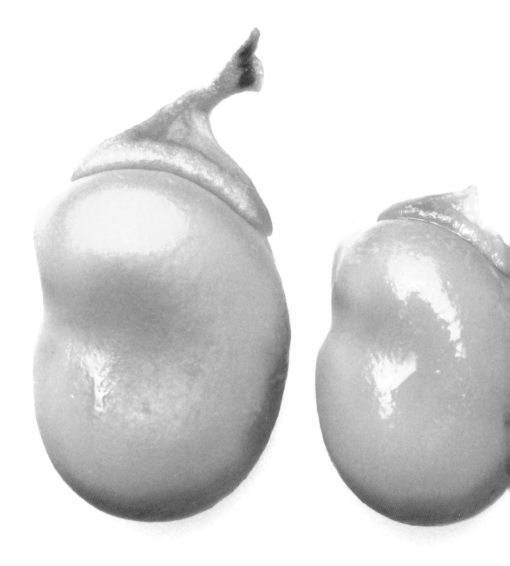

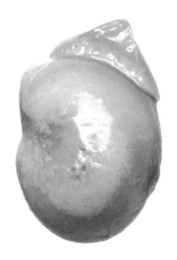

121–1

BROAD BEANS
HABAS
DICKE BOHNEN
HARICOTS
FAVE

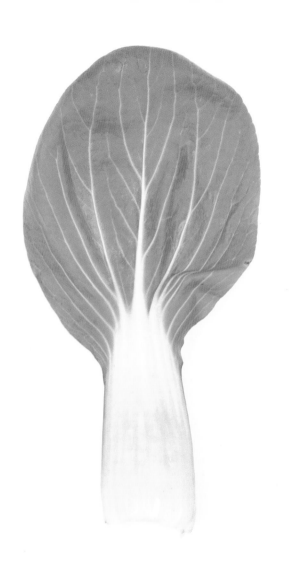

122-1

PAK CHOI
PAK-CHOI
PAK CHOI
PAK CHOI
PAK-CHOI

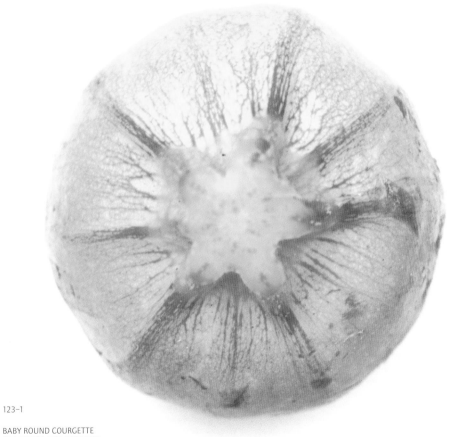

123–1

BABY ROUND COURGETTE
CALABACÍN MINI REDONDO
RUNDER MINI-ZUCCHINO
COURGETTE RONDE MINIATURE
ZUCCHINO ROTONDO

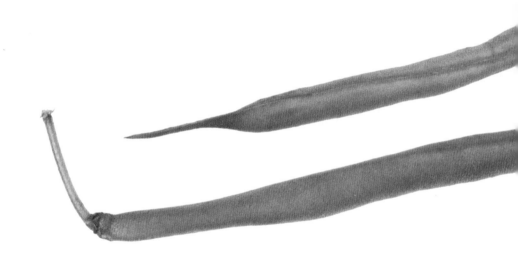

124–1

FINE GREEN BEANS
JUDÍAS VERDES FINAS
GRÜNE BOHNEN
HARICOTS VERTS EXTRA-
FINS

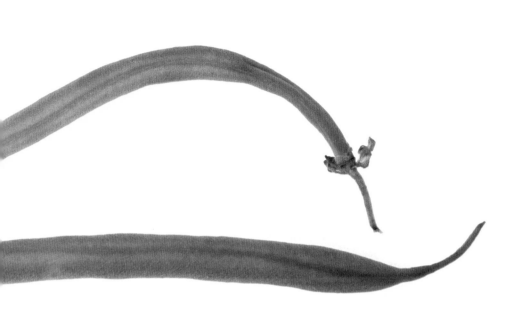

126-1

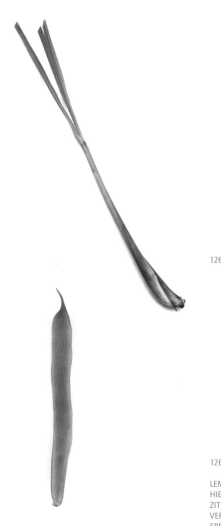

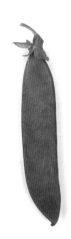

126-2

126-3

126-1	126-2	126-3
LEMON GRASS	MANGETOUT	RUNNER BEAN
HIERBA DE LIMÓN	TIRABEQUE	JUDÍA PERONA
ZITRONENGRAS	ZUCKERERBSEN	STANGENBOHNE
VERVEINE DES INDES	POIS MANGE-TOUT	POIS
ERBA LIMONE	PISELLO DOLCE	FAGIOLO VERDE

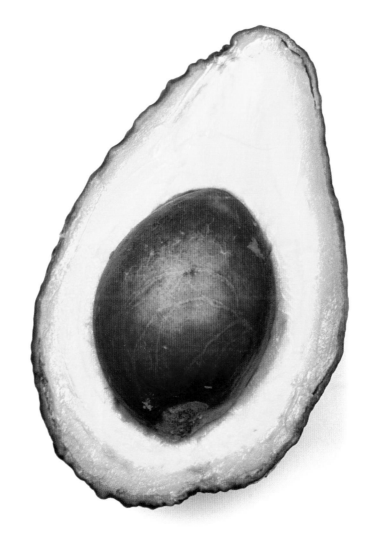

127–1

HAAS AVOCADO
AGUACATE HAAS
AVOCADO HAAS
AVOCAT HAAS
AVOCADO HAAS

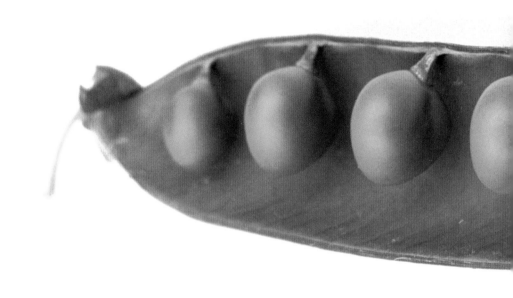

128–1

PEAS
GUISANTES
ERBSEN
PETIT POIS
PISELLI

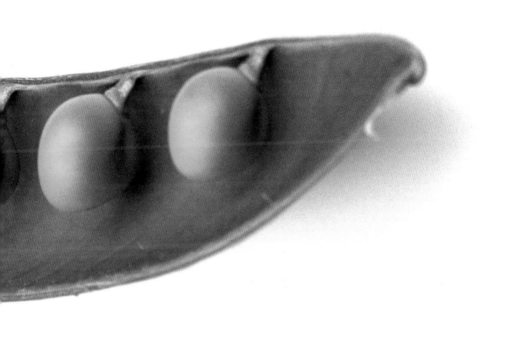

130–1

WILD ROCKET
HOJA DE ORUGA
RUCOLA
ROQUETTE SAUVAGE
RUCOLA

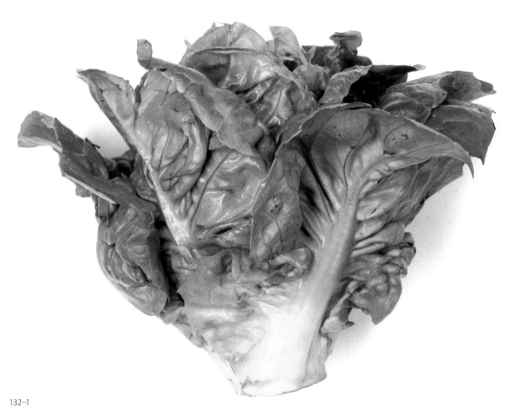

132–1

GREEN OAK LEAF LETTUCE
LECHUGA HOJA DE ROBLE VERDE
GRÜNER EICHBLATTSALAT
LAITUE FEUILLE DE CHÊNE VERTE
LATTUGA VERDE

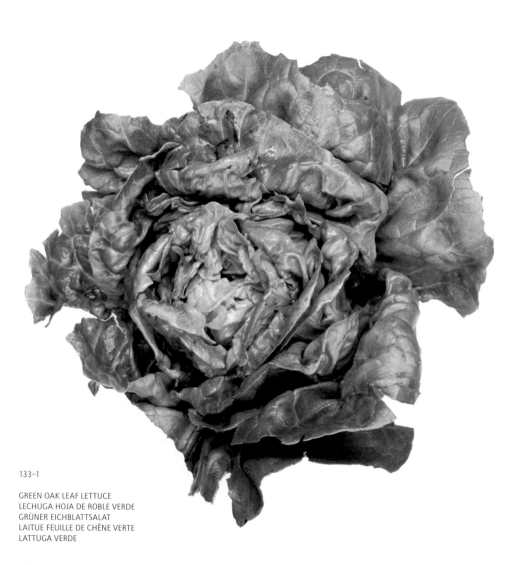

133-1

GREEN OAK LEAF LETTUCE
LECHUGA HOJA DE ROBLE VERDE
GRÜNER EICHBLATTSALAT
LAITUE FEUILLE DE CHÊNE VERTE
LATTUGA VERDE

134–1

CHICKWEED SHOOT
BROTE DE PAMPLINA
HORNKRAUT
POUSSE DE MOURON
GERMOGLIO DI ERBA GALLINA

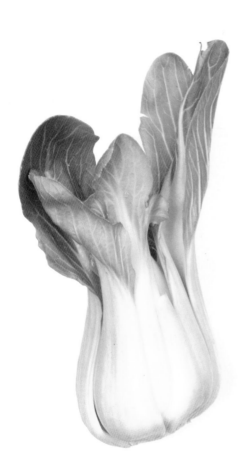

136-2

136-1

136-1	136-2
PAK CHOI	LOLLO VERDE
PAK-CHOI	LOLLO VERDE
PAK CHOI	LOLLO VERDE
PAK CHOI	LOLLO VERDE
PAK-CHOI	LOLLO VERDE

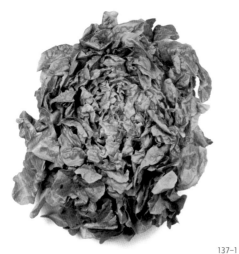

137-1

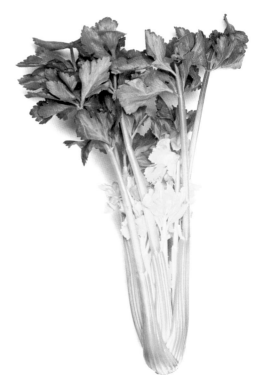

137-1

GREEN OAK LEAF LETTUCE
LECHUGA HOJA DE ROBLE VERDE
GRÜNER EICHBLATTSALAT
LAITUE FEUILLE DE CHÊNE VERTE
LATTUGA VERDE

137-2

CELERY
APIO
SELLERIE
CÉLERI
SEDANO

137-2

138–1

RED ROMAINE LETTUCE LEAF
HOJA DE LECHUGA ROMANA ROJA
BLATT VOM RÖMERSALAT
FEUILLE DE LAITUE ROMAINE
FOGLIA DI LATTUGA ROMANA ROSSA

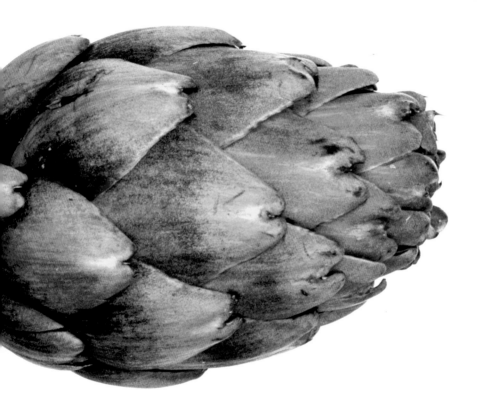

141-1

ARTICHOKE
ALCACHOFA
ARTISCHOCKE
ARTICHAUT
CARCIOFO

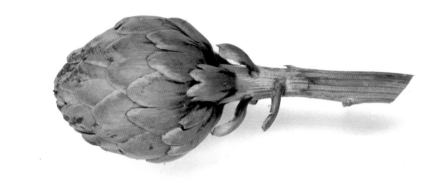

142-2

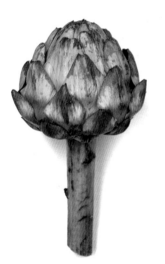

142-1

142-1	142-2
ARTICHOKE	ARTICHOKE
ALCACHOFA	ALCACHOFA
ARTISCHOCKE	ARTISCHOCKE
ARTICHAUT	ARTICHAUT
CARCIOFO	CARCIOFO

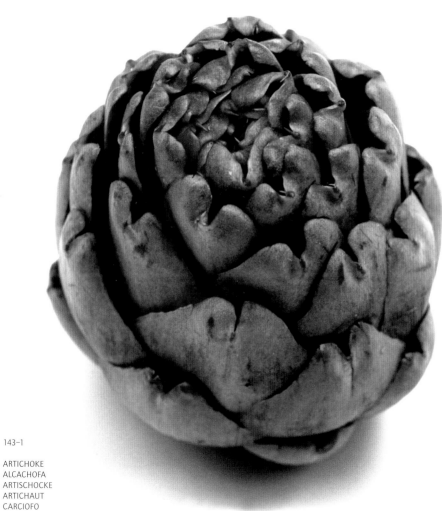

143-1

ARTICHOKE
ALCACHOFA
ARTISCHOCKE
ARTICHAUT
CARCIOFO

144-1

ARTICHOKE
ALCACHOFA
ARTISCHOCKE
ARTICHAUT
CARCIOFO

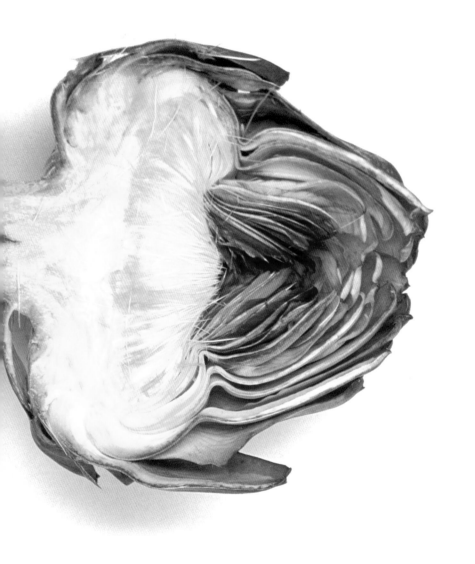

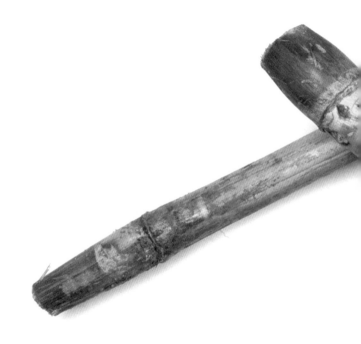

146–1

SUGAR CANE
CAÑA DE AZÚCAR
ZUCKERROHR
CANNE À SUCRE
CANNA DA ZUCCHERO

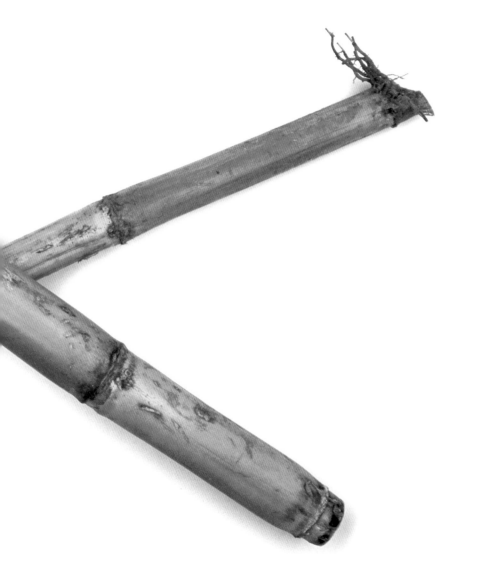

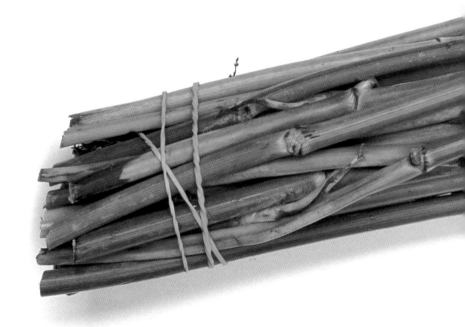

148–1

FENNEL STALKS
HINOJO EN RAMA
FENCHELSTÄNGEL
FENOUIL EN BRANCHES
GAMBI DI FINOCCHIO

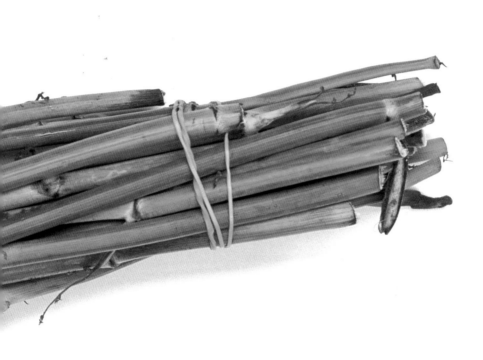

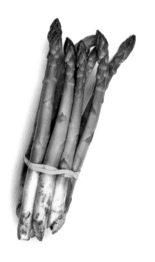

150-1

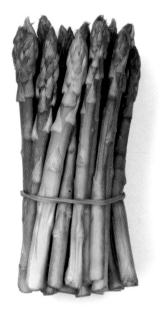

150-2

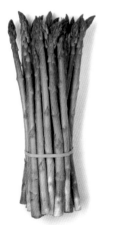

150-3

150-1 150-2	150-3
GREEN ASPARAGUS	WILD ASPARAGUS
ESPÁRRAGO VERDE	ESPÁRRAGOS TRIGUEROS
GRÜNER SPARGEL	WILDER SPARGEL
ASPERGE VERTE	ASPERGES SAUVAGES
ASPARAGO VERDE	ASPARAGO SELVATICO

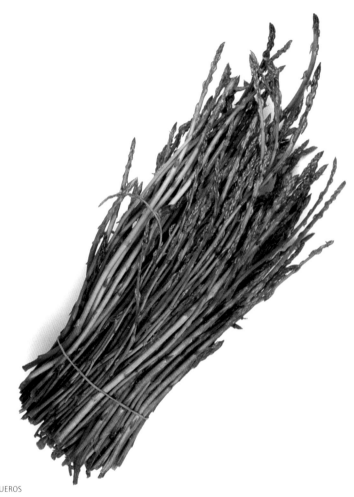

151-1

WILD ASPARAGUS
ESPÁRRAGOS TRIGUEROS
WILDER SPARGEL
ASPERGES SAUVAGES
ASPARAGO SELVATICO

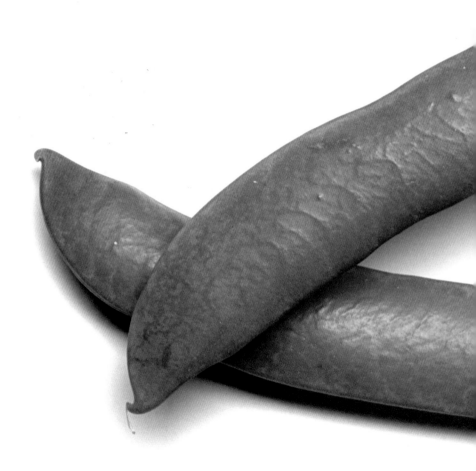

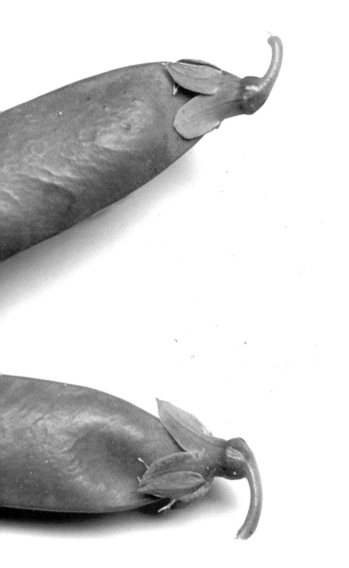

153-1

PEAS
GUISANTES
ERBSEN
PETIT POIS
PISELLI

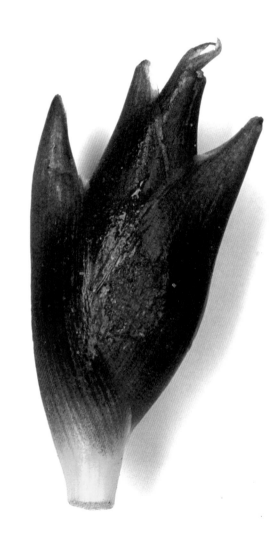

154-1

JAPANESE SCALLION
ESCALUÑA JAPONESA
JAPANISCHE SCHALOTTE
ÉCHALOTTE JAPONAISE
SCALOGNO GIAPPONESE

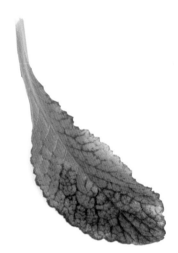

155-1

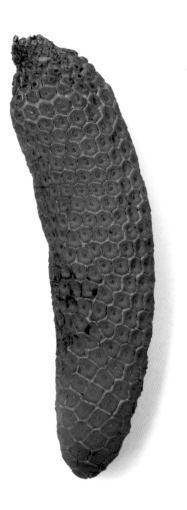

155-1

MUSTARD LEAF
HOJA DE MOSTAZA
BLATT VOM ACKERSENF
FEUILLE DE MOUTARDE
FOGLIA DI SENAPE

155-2

MEXICAN BREADFRUIT
MONSTERA
MONSTERA
MONSTERA
FRUTTA DEL MESSICO

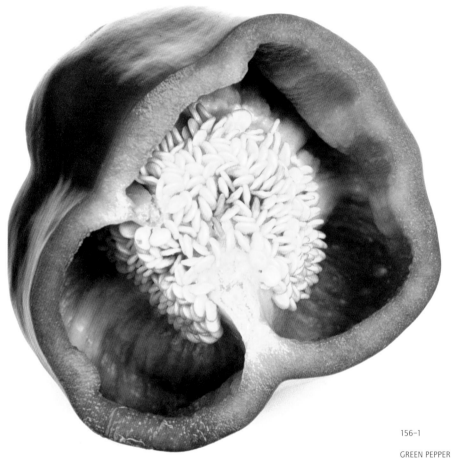

156–1

GREEN PEPPER
PIMIENTO VERDE
GRÜNE PAPRIKA
POIVRON VERT
PEPERONE VERDE

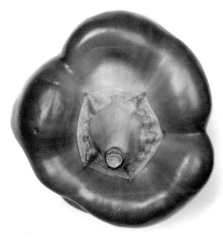

157-1

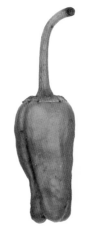

157-2

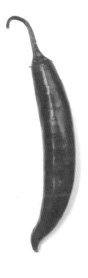

157-3

157-1	157-2	157-3
GREEN PEPPER	GREEN CHILLI PEPPER	PADRON PEPPER
PIMIENTO VERDE	CHILE VERDE	PIMIENTO DEL PADRÓN
GRÜNER PAPRIKA	GRÜNE CHILISCHOTE	PIMIENTO DE PADRÓN
POIVRON VERT	PIMENT VERT	PIMENT "DEL PADRON"
PEPERONE VERDE	PEPERONCINO VERDE	PEPERONCINO VERDE VARIETÀ "PADRÓN"

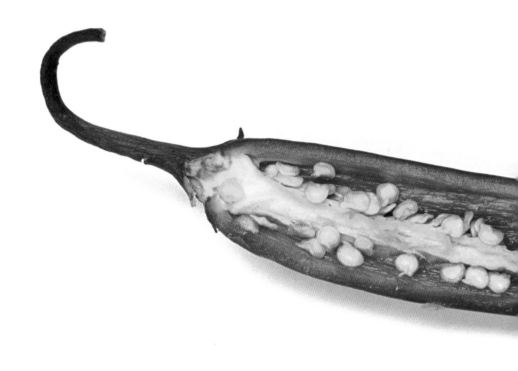

158-1

GREEN CHILLI PEPPER
CHILE VERDE
GRÜNE CHILISCHOTE
PIMENT VERT
PEPERONCINO VERDE

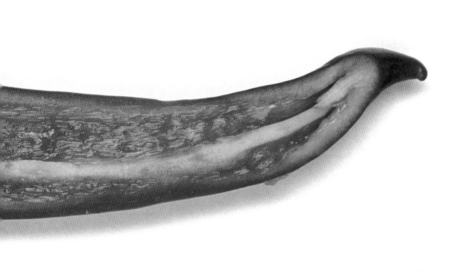

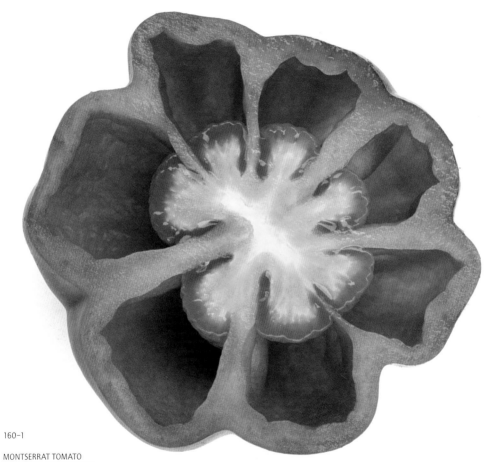

160-1

MONTSERRAT TOMATO
TOMATE DE MONTSERRAT
MONTSERRAT-TOMATE
TOMATE DE MONTSERRAT
POMODORO TIPO MONTSERRAT

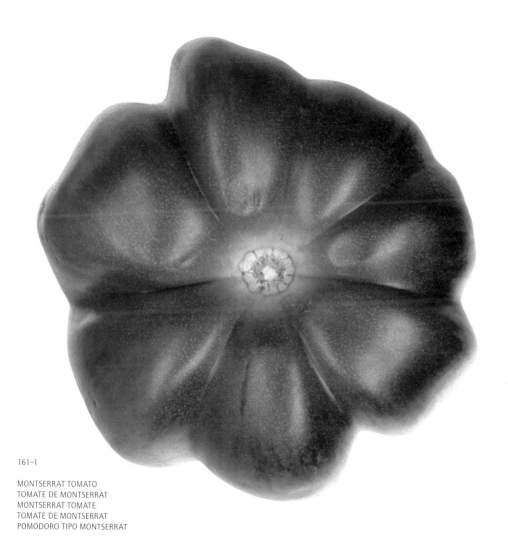

161-1

MONTSERRAT TOMATO
TOMATE DE MONTSERRAT
MONTSERRAT-TOMATE
TOMATE DE MONTSERRAT
POMODORO TIPO MONTSERRAT

162–1

ITALIAN GREEN PEPPER
PIMIENTO VERDE ITALIANO
ITALIENISCHER GRÜNER PAPRIKA
POIVRON VERT D'ITALIE
POMODORO VERDE

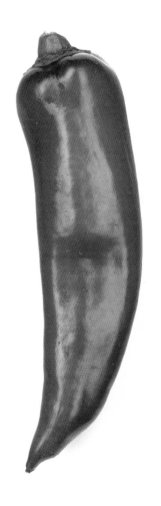

164-1

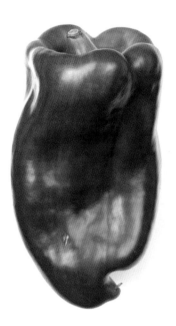

164-2

164-1

ITALIAN GREEN PEPPER
PIMIENTO VERDE ITALIANO
ITALIENISCHER GRÜNER PAPRIKA
POIVRON VERT D'ITALIE
POMODORO VERDE

164-2

GREEN BELL PEPPER
PIMIENTO VERDE
GRÜNER PAPRIKA
POIVRON VERT
PEPERONE VERDE

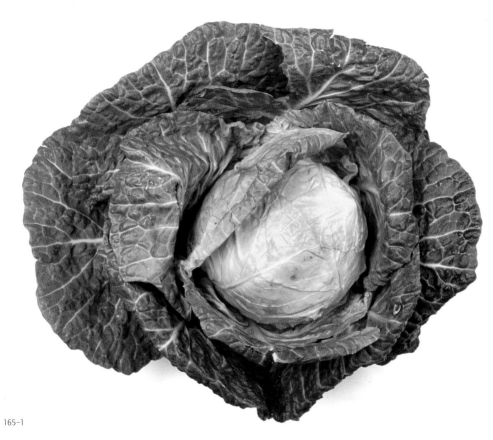

165–1

SAVOY CABBAGE
COL DE HOJA RIZADA
WIRSING
CHOU FRISÉ
CAVOLO A FOGLIA RICCIA

166-1

MARROW-STEMMED KALE
COL FORRAJERA
MARKSTAMMKOHL
CHOU FOURRAGER
CAVOLO DA FORAGGIO

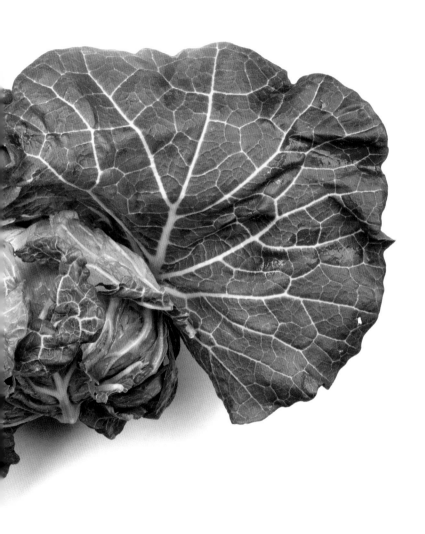

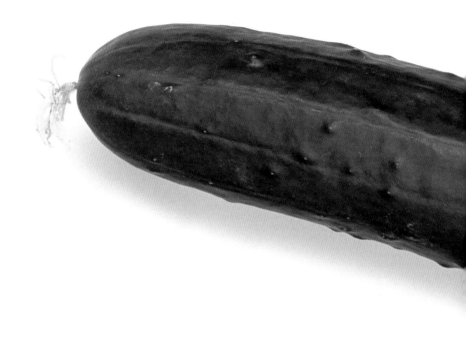

168-1

CUCUMBER
PEPINO
GURKE
CONCOMBRE
CETRIOLO

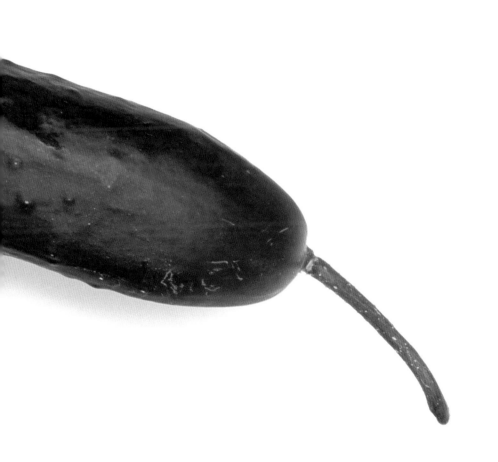

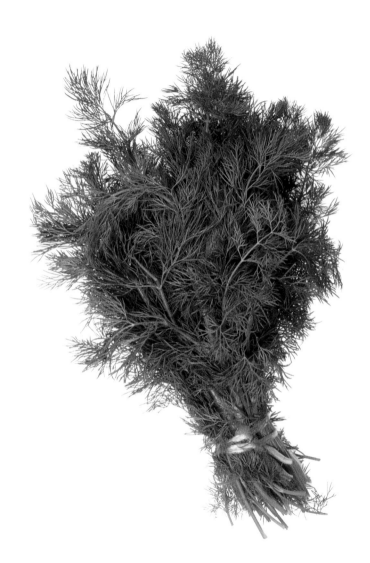

170-1

DILL
ENELDO
DILL
ANETH
ANETO

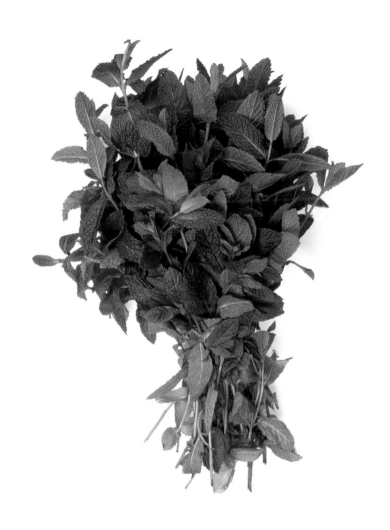

171–1

FRESH MINT
MENTA
MINZE
MENTHE
MENTA

172–1

172–2

172–3

172–1	172–2	172–3
THYME	CHIVES	TARRAGON
TOMILLO	CEBOLLINO	ESTRAGÓN
THYMIAN	SCHNITTLAUCH	ESTRAGON
THYM	CIBOULETTE	ESTRAGON
TIMO	ERBA CIPOLLINA	DRAGONCELLO

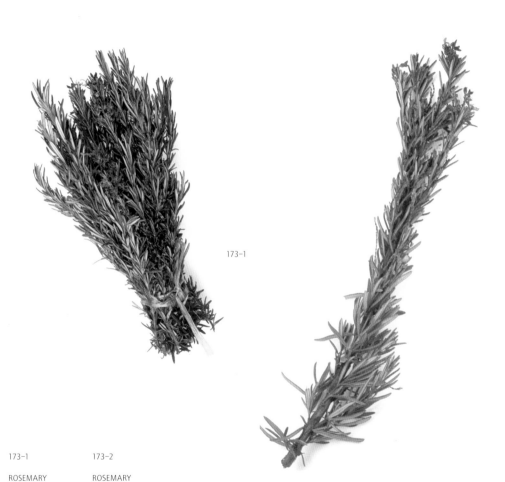

173-1

173-1

173-2

ROSEMARY
ROMERO
ROSMARIN
ROMARIN
ROSMARINO

ROSEMARY
ROMERO
ROSMARIN
ROMARIN
ROSMARINO

173-2

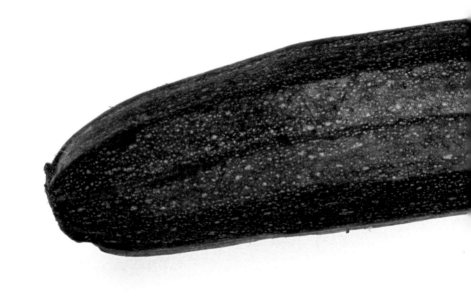

174–1

COURGETTE
CALABACÍN
ZUCCHINO
COURGETTE
ZUCCHINO

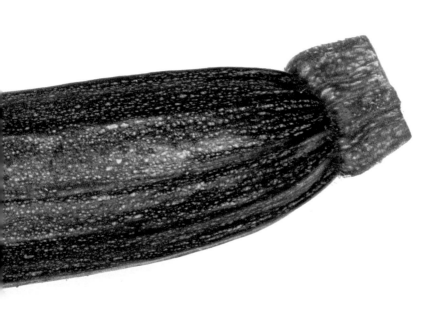

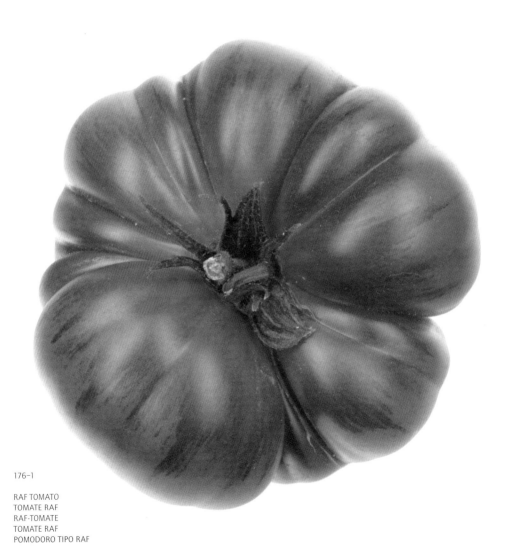

176–1

RAF TOMATO
TOMATE RAF
RAF-TOMATE
TOMATE RAF
POMODORO TIPO RAF

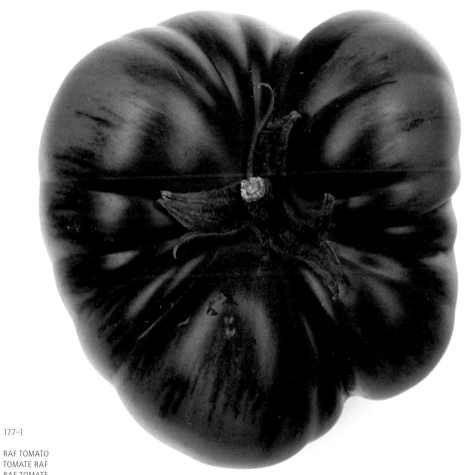

177–1

RAF TOMATO
TOMATE RAF
RAF-TOMATE
TOMATE RAF
POMODORO TIPO RAF

180-1

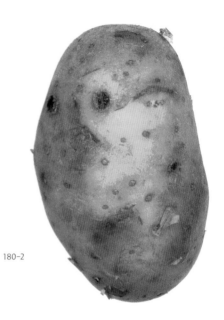

180-2

180-1	180-2
RATTE POTATO	BARTINE POTATO
PATATA RATTE	PATATA BARTINE
LA RATTE-KARTOFFEL	BARTINE-KARTOFFEL
POMME DE TERRE RATTE	POMME DE TERRE BARTINE
PATATA TIPO RATTE	PATATA TIPO BARTINE

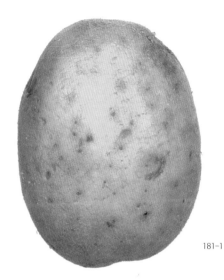

181-1

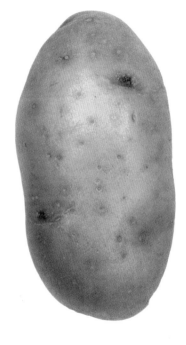

181-1

ACCENT POTATO
PATATA ACCENT
ACCENT-KARTOFFEL
POMME DE TERRE ACCENT
PATATA TIPO ACCENT

181-1

MARFONA POTATO
PATATA MARFONA
MARFONA-KARTOFFEL
POMME DE TERRE MARFONA
PATATA TIPO MARFONA

182–1

TAMARIND
TAMARINDO
TAMARINDE
TAMARIND
TAMARINDO

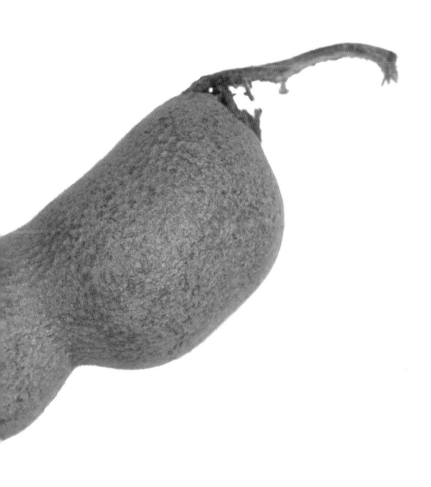

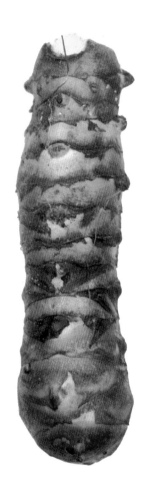

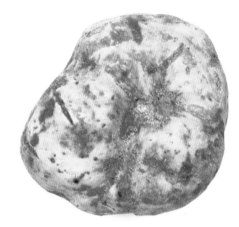

184-2

184-1

184-1

JERUSALEM ARTICHOKE
AGUATURMA
JERUSALEM-ARTISCHOCKE
ARTICHAUT DE JÉRUSALEM
TOPINAMBUR

184-2

WHITE PIEMONT TRUFFLE
TRUFA BLANCA DEL PIAMONTE
WEIßE PIEMONT-TRÜFFEL
TRUFFE BLANCHE DU PIÉMONT
TARTUFO BIANCO DEL PIEMONTE

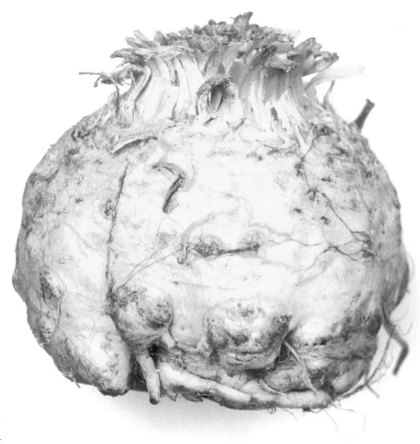

185-1

CELERIAC
APIO-NABO
KNOLLENSELLERIE
CÉLERI-RAVE
SEDANO RAPA

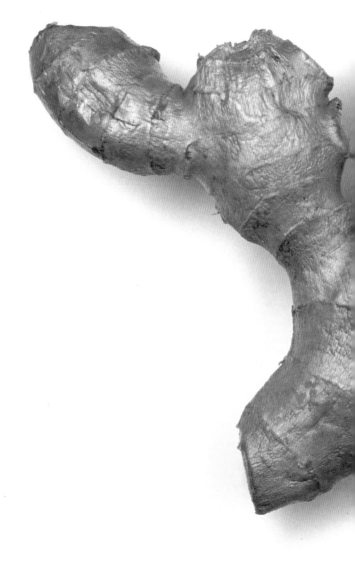

186-1

FRESH GINGER
JENGIBRE
INGWER
GINGEMBRE
ZENZERO

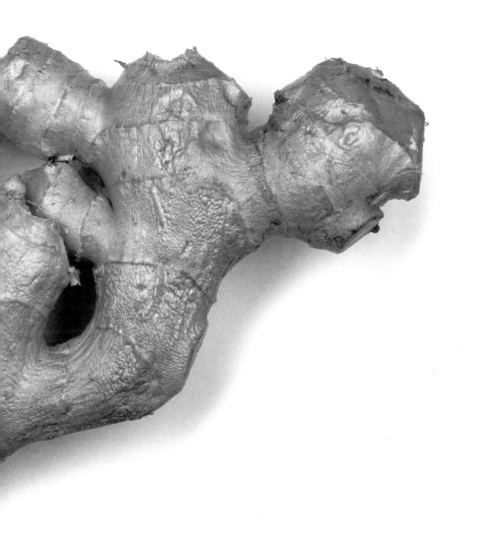

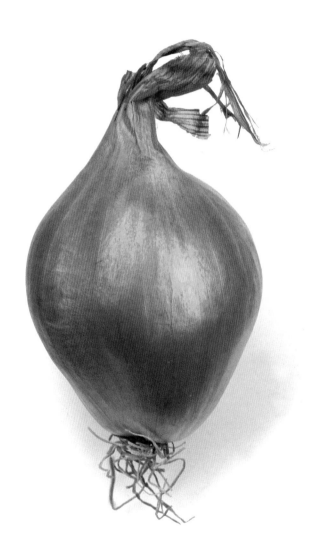

188-1

SHALLOT
AJO CHALOTE
SCHALOTTE
ÉCHALOTE
ACALOGNO

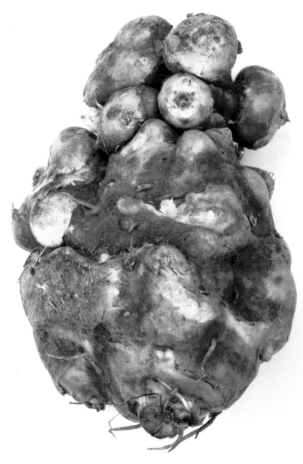

189-1

JERUSALEM ARTICHOKE
AGUATURMA
JERUSALEM-ARTISCHOCKE
ARTICHAUT DE JÉRUSALEM
TOPINAMBUR

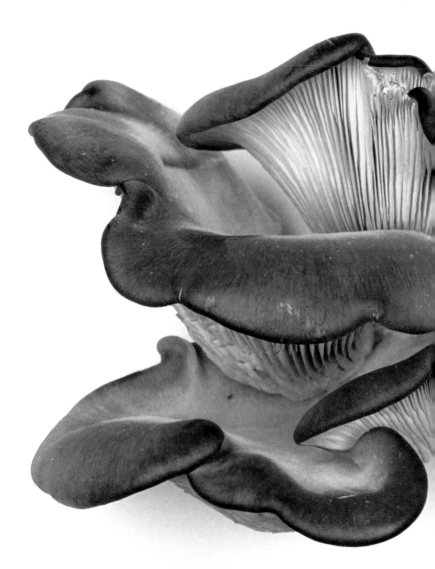

OYSTER MUSHROOM
PLEUROTO
AUSTERNPILZ
PLEUROTE
GELONE

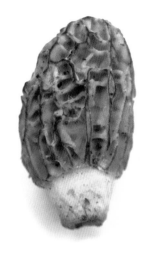

192-1

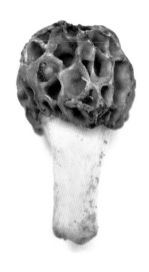

192-2

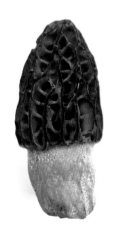

192-3

192-1	192-2	192-3
MOREL	MOREL	MOREL
COLMENILLA	COLMENILLA	COLMENILLA
MORCHEL	MORCHEL	MORCHEL
MORILLE	MORILLE	MORILLE
SPUGNOLA	SPUGNOLA	SPUGNOLA

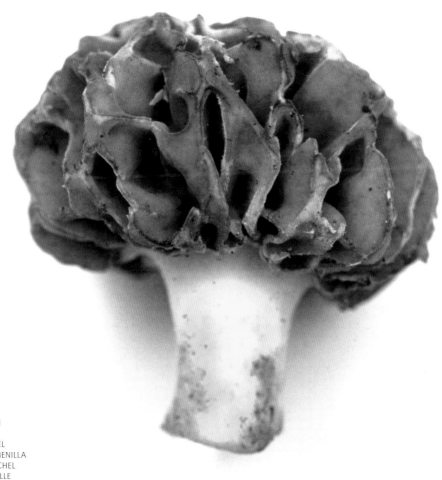

193–1

MOREL
COLMENILLA
MORCHEL
MORILLE
SPUGNOLA

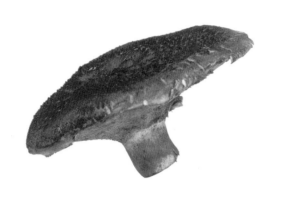

194-1

194-2

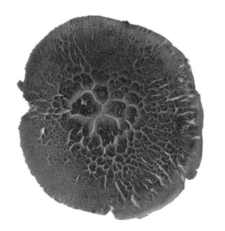

194-3

194-1	194-2	194-3
SARCODON	SARCODON	SARCODON
SARCODON	SARCODON	SARCODON
SARCODON	SARCODON	SARCODON
SARCODON	SARCODON	SARCODON
SARCODON	SARCODON	SARCODON

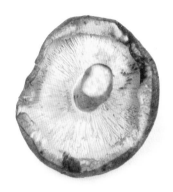

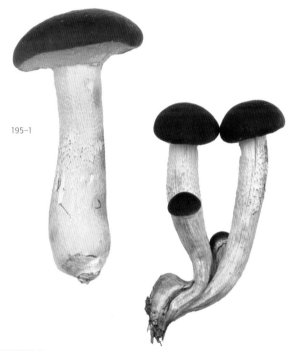

195-1

195-2

195-1

HYGROPHORUS LIMACINUS
HIGROFORO
HYGROPHORUS LIMACINUS
HYGROPHORE LIMACE
HYGROPHORUS LIMACINUS

195-2

PIOPPINO MUSHROOMS
SETAS DE CHOPO DE CULTIVO
SCHÜPPLING
PHOLIOTE DU PEUPLIER
FOLIOTA DEL PIOPPO

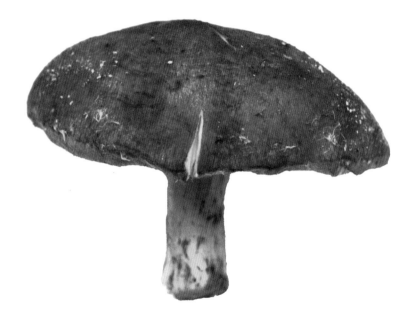

196-1

HYGROPHORUS LIMACINUS
HIGROFORO
HYGROPHORUS LIMACINUS
HYGROPHORE LIMACE
HYGROPHORUS LIMACINUS

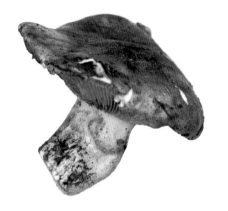

197-1

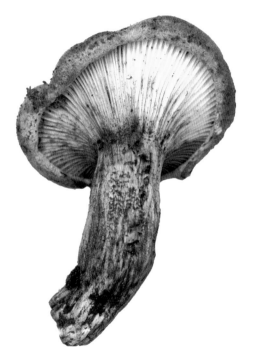

197-1

SHIITAKE MUSHROOM
SHIITAKE
SHIITAKE-PILZ
SHIITAKE
SHII TAKE

197-2

SHIITAKE MUSHROOM
SHIITAKE
SHIITAKE-PILZ
SHIITAKE
SHII TAKE

197-2

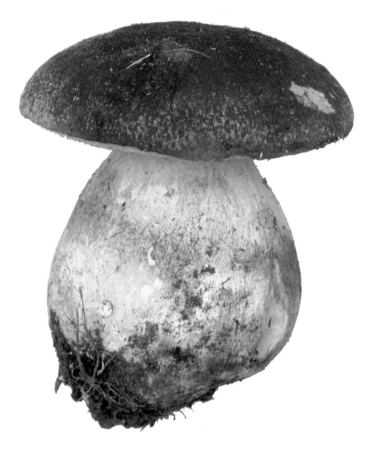

198–1

CEP
BOLETO COMESTIBLE
STEINPILZ
BOLET COMESTIBLE
PORCINO COMMESTIBILE

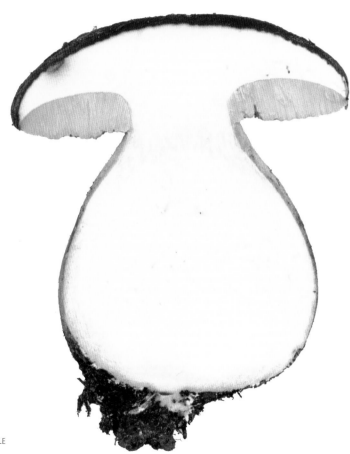

199-1

CEP
BOLETO COMESTIBLE
STEINPILZ
BOLET COMESTIBLE
PORCINO COMMESTIBILE

200-1

200-2

200-3

200-1	200-2	200-3
BLUE POTATO	SWEET POTATO	TARO ROOT
PATATA VIOLETA	BONIATO	TARO
BLAUE KARTOFFEL	SÜßKARTOFFEL	TARO-WURZEL
POMME DE TERRE VIOLETTE	PATATE DOUCE	RACINE DE TARO
PATATA ROSSA	PATATA AMERICANA	COLOCASIA O TARO

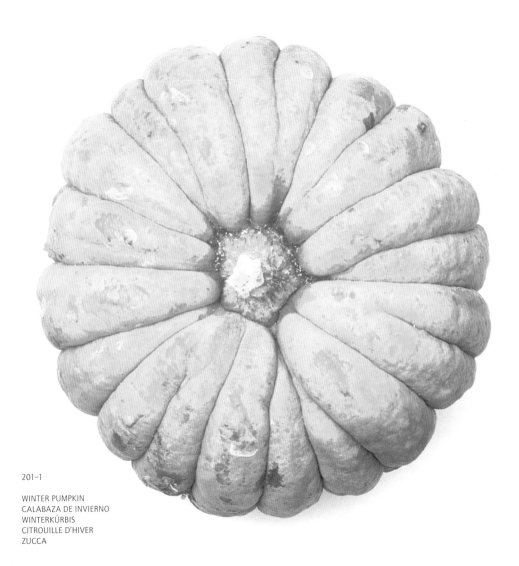

201-1

WINTER PUMPKIN
CALABAZA DE INVIERNO
WINTERKÜRBIS
CITROUILLE D'HIVER
ZUCCA

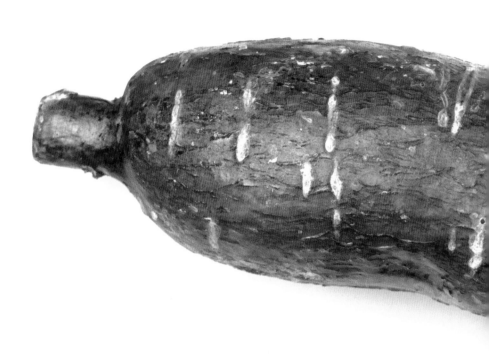

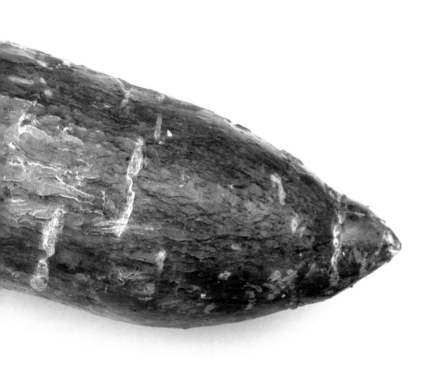

203-1

YUCCA
YUCA
YUCCA
YUCA
YUCA

204–1

SALSIFY
SALSIFÍ
SCHWARZWURZELN
SALSIFI
SALSEFRICA

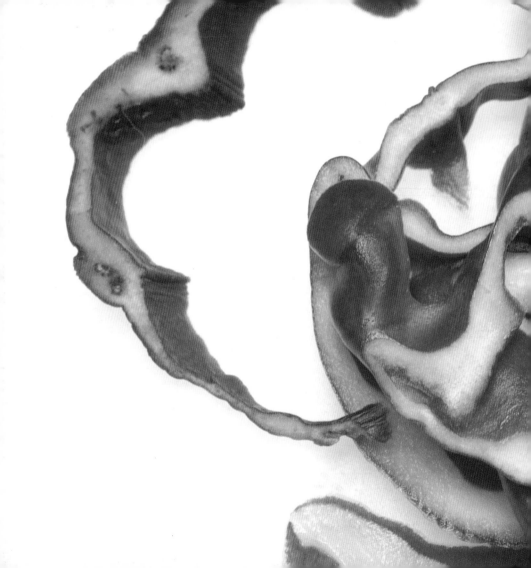

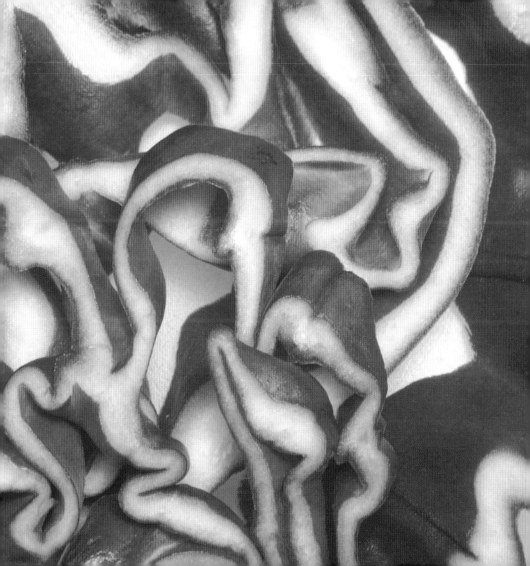

208-2

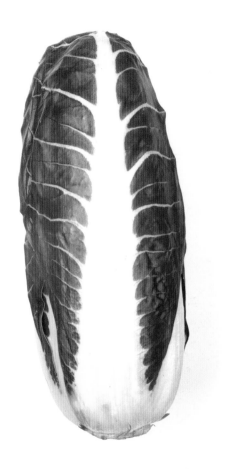

208-1

208-1	208-2
RADICCHIO	RED CABAGGE
RADICCHIO	COL LOMBARDA
RADICCHIO	ROTKOHL
RADICCHIO	CHOU ROUGE
RADICCHIO	CAVOLO VERZA

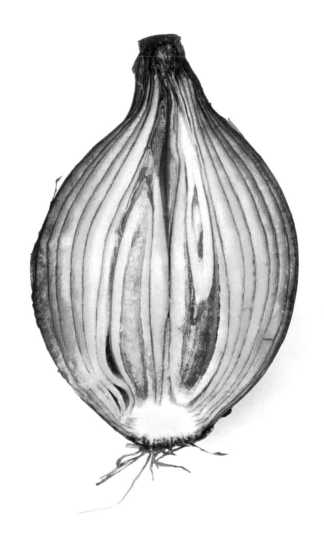

209–1

ITALIAN RED ONION
CEBOLLA ROJA
ROTE ZWIEBEL
OIGNON ROUGE D'ITALIE
CIPOLLA ROSSA

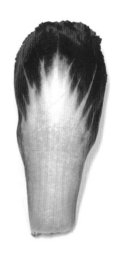

210-2

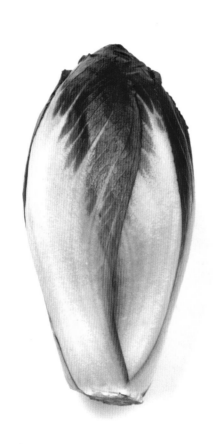

210-1

210-1	210-2
RED CHICORY	RED CHICORY
ENDIBIA ROJA	ENDIBIA ROJA
ROTER CHICORÉE	ROTER CHICORÉE
ENDIVE ROUGE	ENDIVE ROUGE
INDIVIA ROSSA	INDIVIA ROSSA

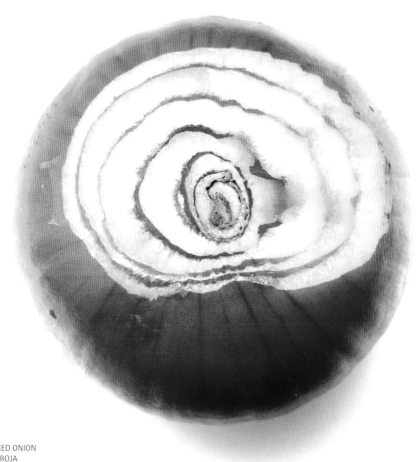

211-1

ITALIAN RED ONION
CEBOLLA ROJA
ROTE ZWIEBEL
OIGNON ROUGE
CIPOLLA ROSSA

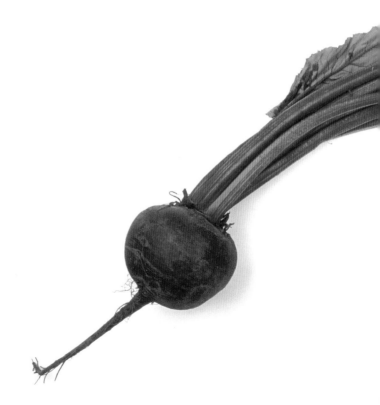

212–1

BEETROOT
REMOLACHA
ROTE BEETE
BETTERAVE ROUGE
BARBABIETOLA

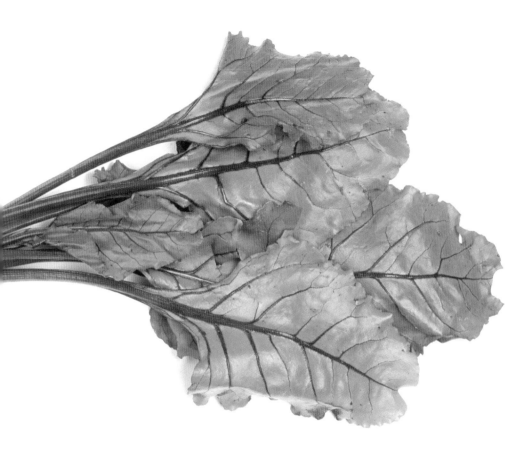

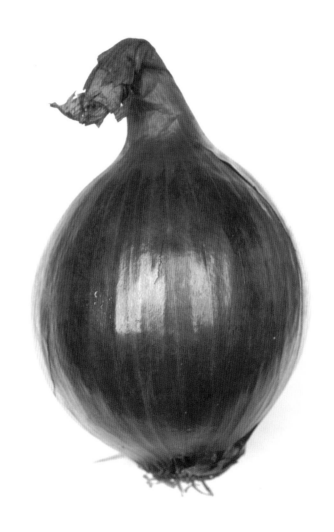

214-1

ITALIAN RED ONION
CEBOLLA ROJA
ROTE ZWIEBEL
OIGNON ROUGE
CIPOLLA ROSSA

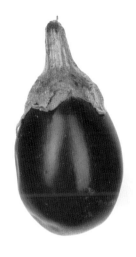

215–1

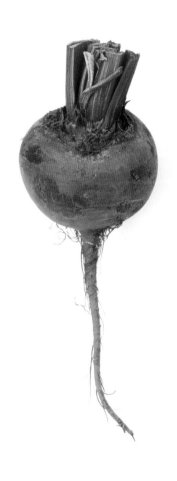

215–1

BABY AUBERGINE
BERENJENA MINI
MINI-AUBERGINE
AUBERGINE MINIATURE
MELANZANA PICCOLA

215–2

BEETROOT
REMOLACHA
ROTE BEETE
BETTERAVE ROUGE
BARBABIETOLA

215–2

216-1

RED CHARD LEAF
HOJA DE ACELGA ROJA
BLATT VON ROTEM MANGOLD
FEUILLE DE BETTE ROUGE
FOGLIA DI BIETOLA ROSSA

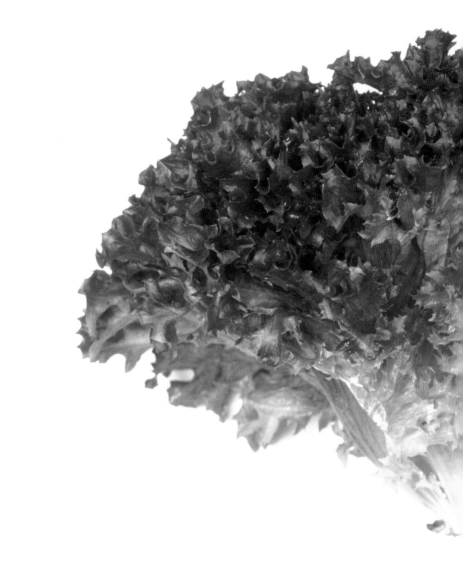

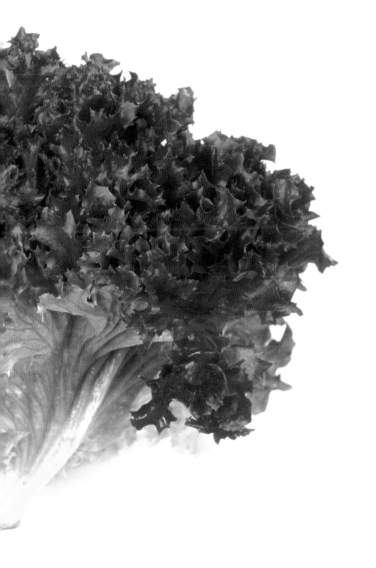

219-1

LOLLO ROSSO
LOLLO ROSSO
LOLLO ROSSO
LOLLO ROSSO
LOLLO ROSSO

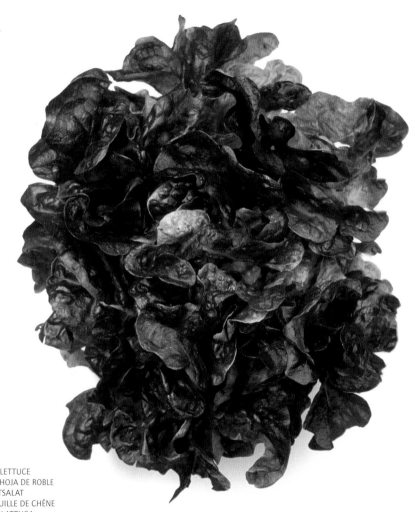

220–1

OAK LEAF LETTUCE
LECHUGA HOJA DE ROBLE
EICHBLATTSALAT
LAITUE FEUILLE DE CHÊNE
FOGLIA DI LATTUGA

221-1

221-2

221-1 221-2 221-3

BLUE POTATO
PATATA VIOLETA
BLAUE KARTOFFEL
POMME DE TERRE VIOLETTE
PATATA ROSSA

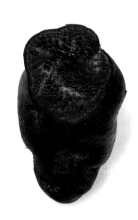

221-3

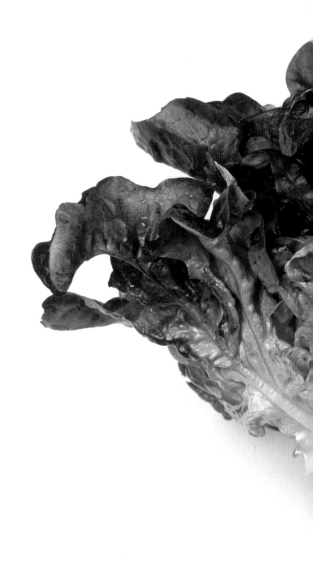

222-1

OAK LEAF LETTUCE
LECHUGA HOJA DE ROBLE
EICHBLATTSALAT
LAITUE FEUILLE DE CHÊNE
LATTUGA

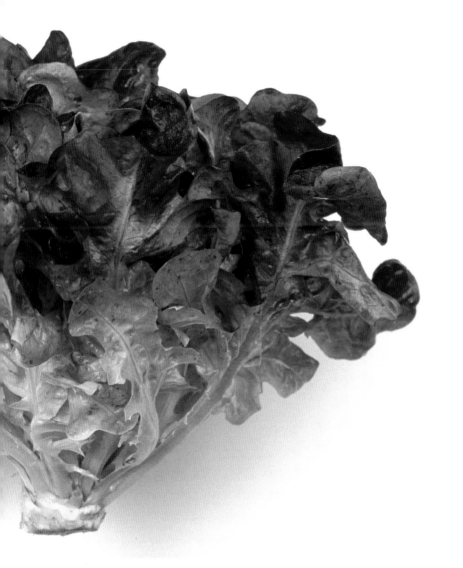

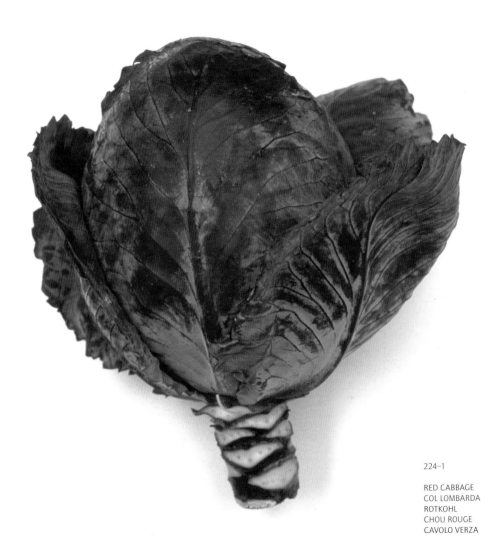

224-1

RED CABBAGE
COL LOMBARDA
ROTKOHL
CHOU ROUGE
CAVOLO VERZA

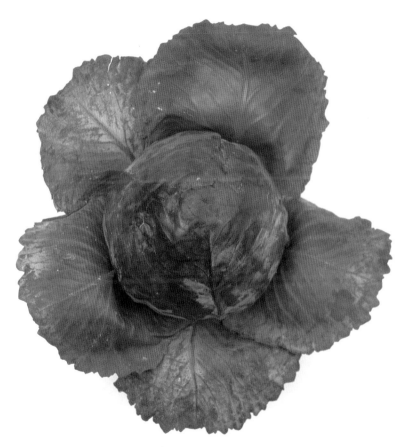

225–1

RED CABBAGE
COL LOMBARDA
ROTKOHL
CHOU ROUGE
CAVOLO VERZA

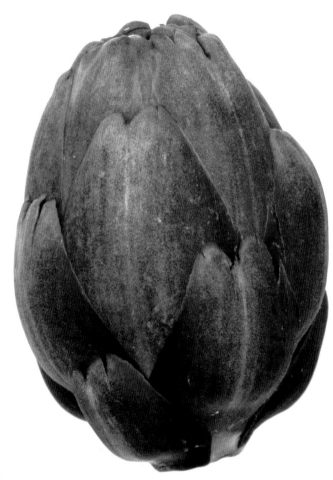

226-1

BABY ARTICHOKE
ALCACHOFA MINI
MINI-ARTISCHOCKE
ARTICHAUT MINIATURE
CARCIOFO PICCOLO

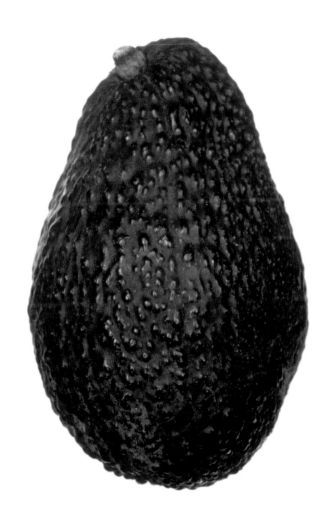

227–1

HAAS AVOCADO
AGUACATE HAAS
AVOCADO HAAS
AVOCAT HAAS
AVOCADO HAAS

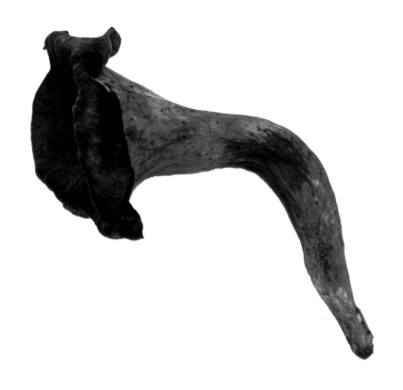

228–1

BLACK TRUMPET MUSHROOM
TROMPETA DE LOS MUERTOS
TOTENTROMPETE
TROMPETTE DE LA MORT
TROMBETTA DEI MORTI

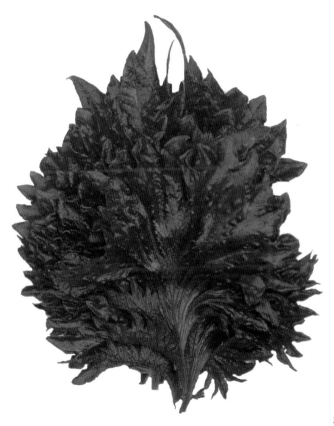

229–1

SISHO LEAF
HOJA DE SISHO
SISHO-BLATT
FEUILLE DE SISHO
FOGLIA DI SISHO

230–1

PURPLE BASIL
ALBAHACA PÚR-
PURA
ROTES BASILIKUM
BASILIC POURPRE

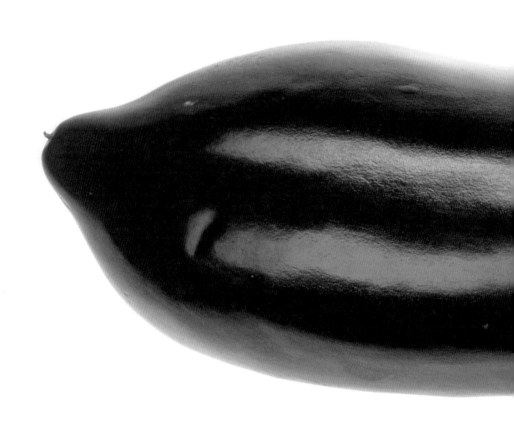

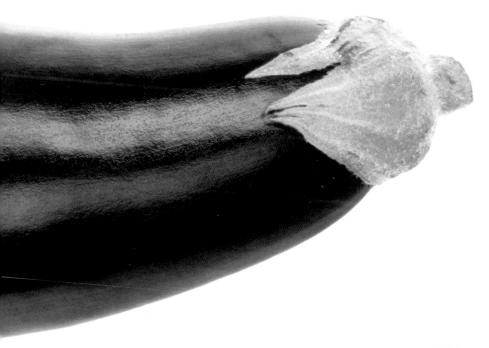

233–1

AUBERGINE
BERENJENA
AUBERGINE
AUBERGINE
MELANZANA

INDEX

ÍNDICE

INDEX

241

INDEX

INDICE